As I Walked the Beach Today...

Padre Island Pictures & Poetry

Clemmie-Li Clyde

Halo
PUBLISHING
INTERNATIONAL

Halo Publishing International
7550 WIH-10 #800, PMB 2069,
San Antonio, TX 78229

First Edition, October 2023
ISBN: 978-1-63765-488-0
Library of Congress Control Number: 2023916557

Halo Publishing International is a self-publishing company that publishes adult fiction and non-fiction, children's literature, self-help, spiritual, and faith-based books. Do you have a book idea you would like us to consider publishing? Please visit www.halopublishing.com for more information.

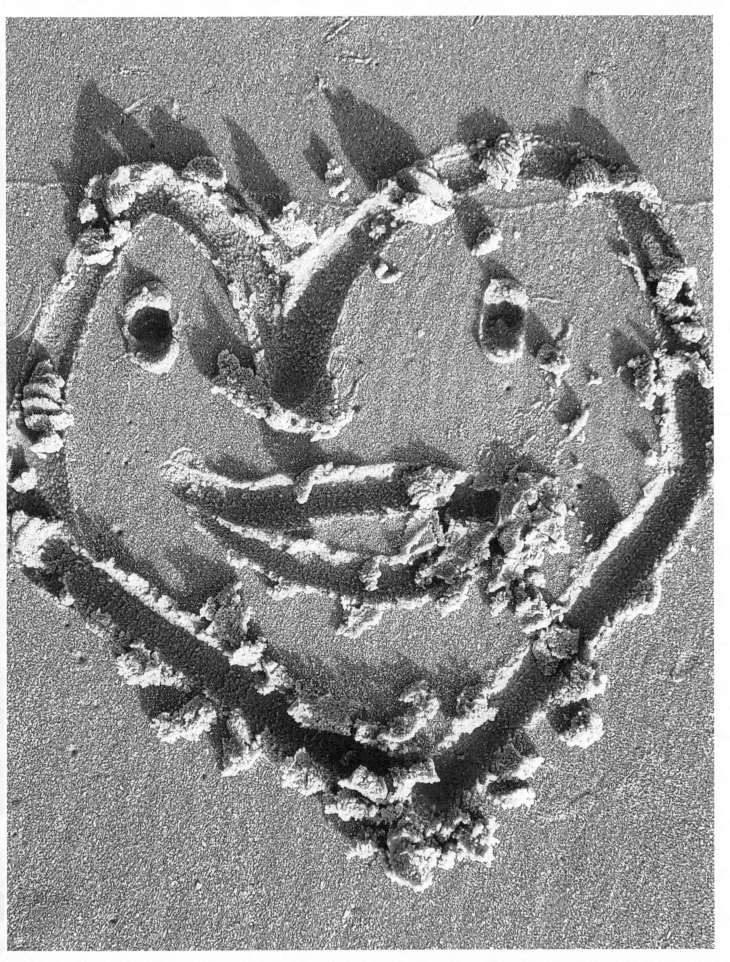

For my grands, may you forever enjoy Gran-Li's Beach!

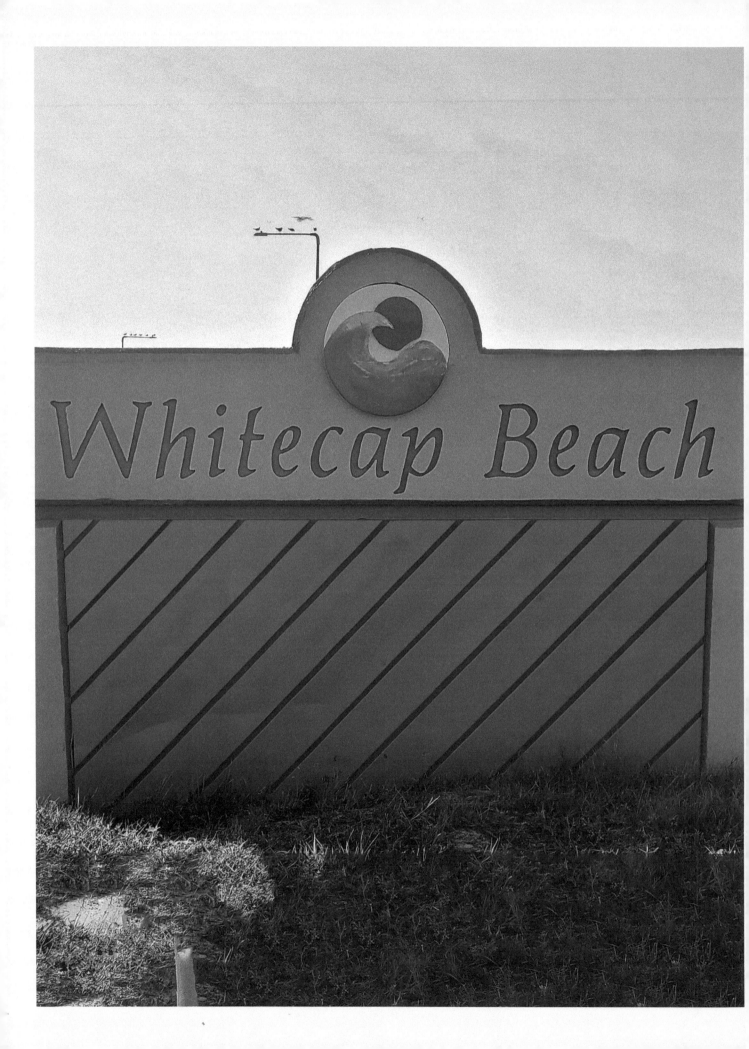

Preface

It was October 2019, and I officially became an Island Girl!
Walking along the Corpus Christi, Texas, coast each morning
since has produced surprises. Whitecap Beach, aka Gran-Li's
Beach—so nicknamed by the grandkiddos—is part of my daily
life. My camera is always ready and present to capture a pic of
the latest treasures awaiting to be discovered. Sprinkled amidst the
photos are sweet, simple, silly poems inspired along the way.

My hope is that the beauty held in this book will shine a ray of light
into your life and inspire you to notice the blessings around you
and the creativity within you!

The game's afoot! Come along. We never know what we're gonna find!

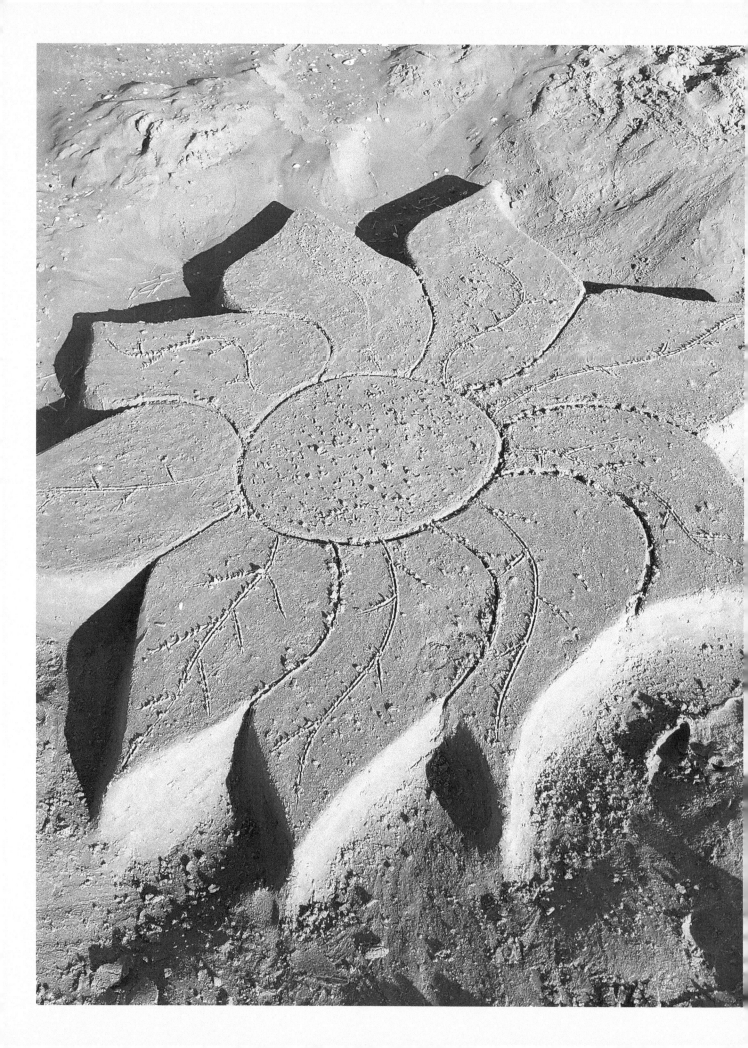

Contents

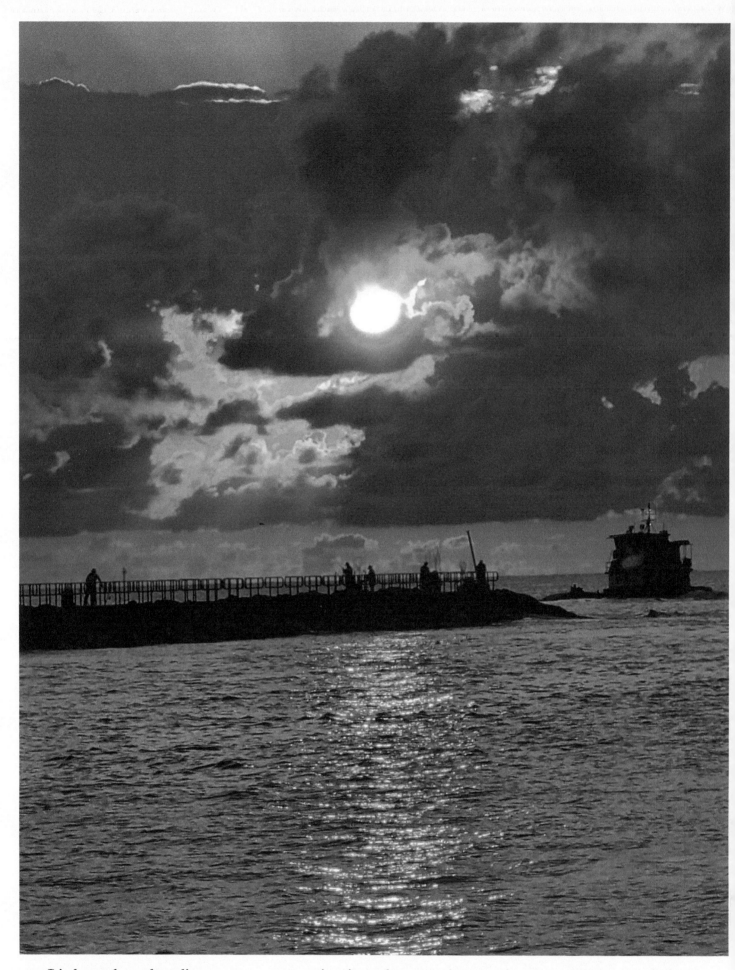

Little tugboat heading out to sea, turning into the morning sun just beyond the north jetty!

I Spy

As I walked the beach today
I played I Spy with My Little Eye.

A sunshine ray,
A bird in the sky,
A tugboat heading out to sea.

Frothy foam,
Whitecapped waves,
Sand dollars,
Shells,
And glass in the sand.
Snapping pictures with the phone in my hand.

Blue, pink, green, and brown,
Bollards sticking out of the ground.

Hotels perched along the seawall,
I'll keep going—I want to mention it all!

Beached jellyfish dot the seashore.
So much to see on this morning, galore!

Sunshine

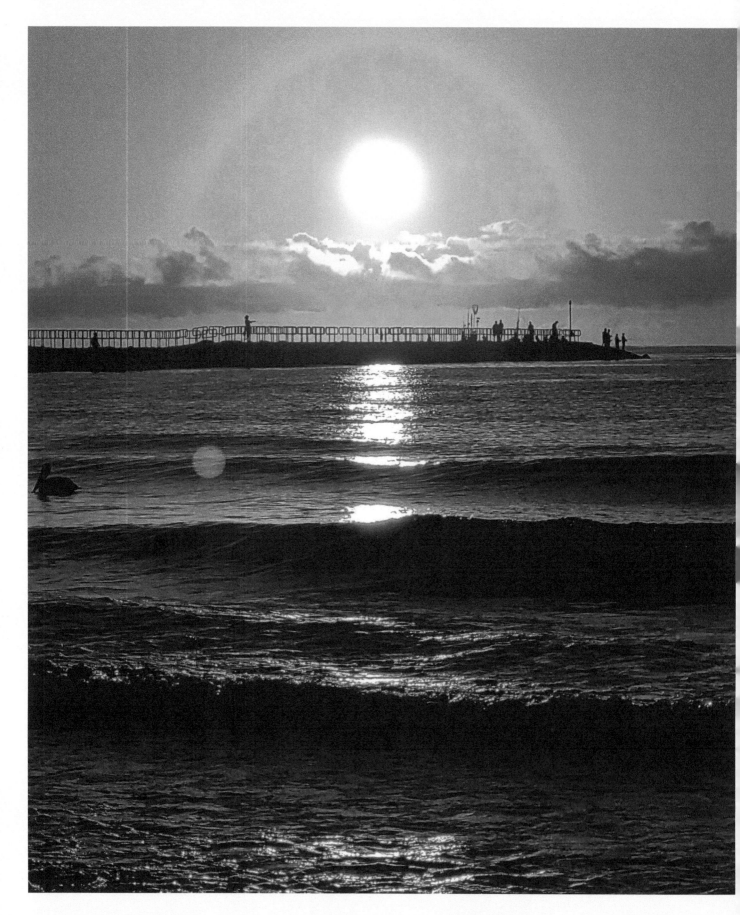

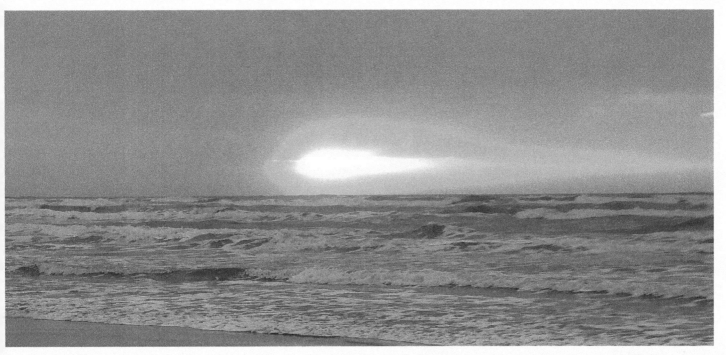

Clouds streaking the new light sideways.

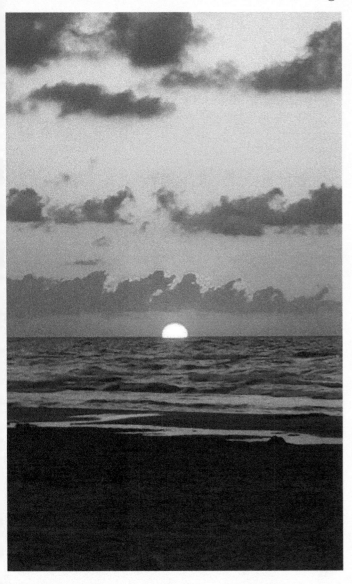

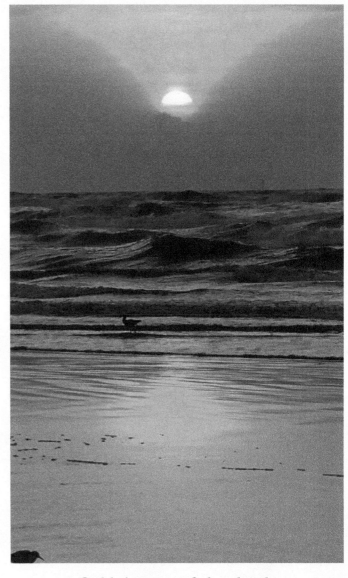

Pink morning sun peeking out of the water

Gold rises out of the clouds.

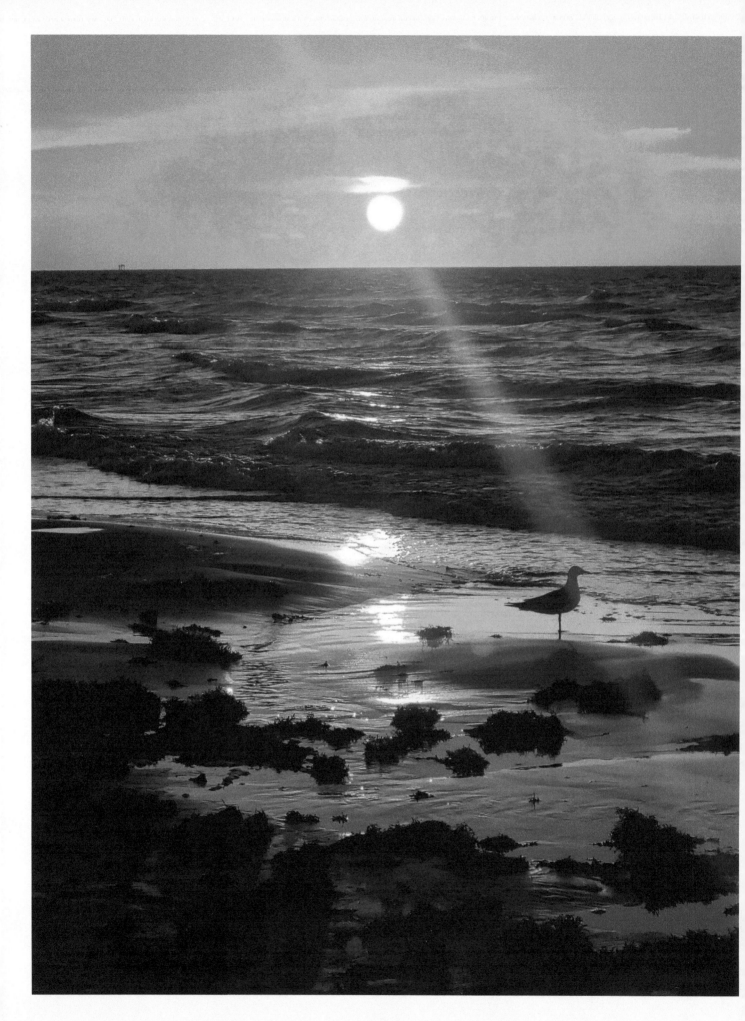

Dripping Gold

As I walked the beach today,
The sun looked like dripping gold.

Casting out its beautiful rays,
The painted sky ready to unfold.

My feet splashed along the way;
The sand squished between my toes.

Energy to my soul, filling away,
My deep connection—untold!

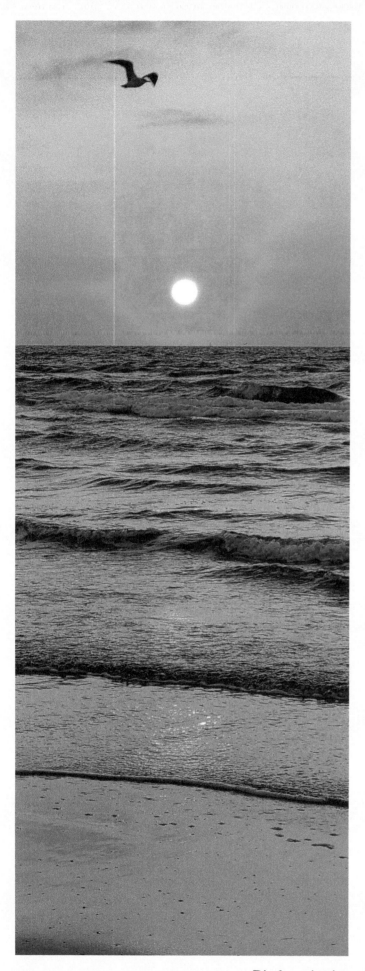
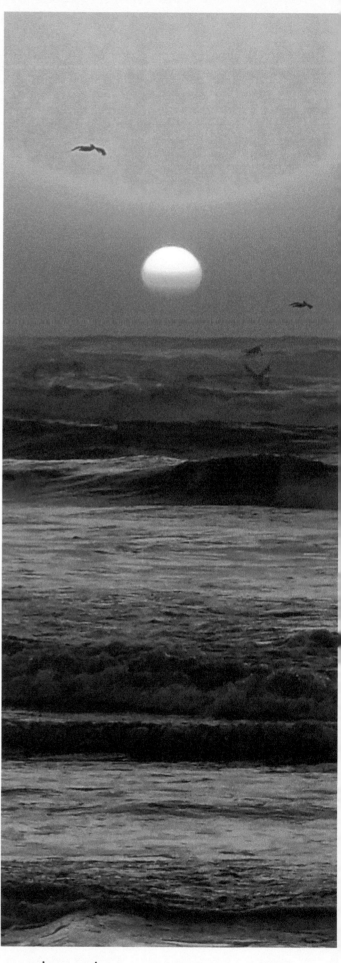

Birds enjoying the morning sun!

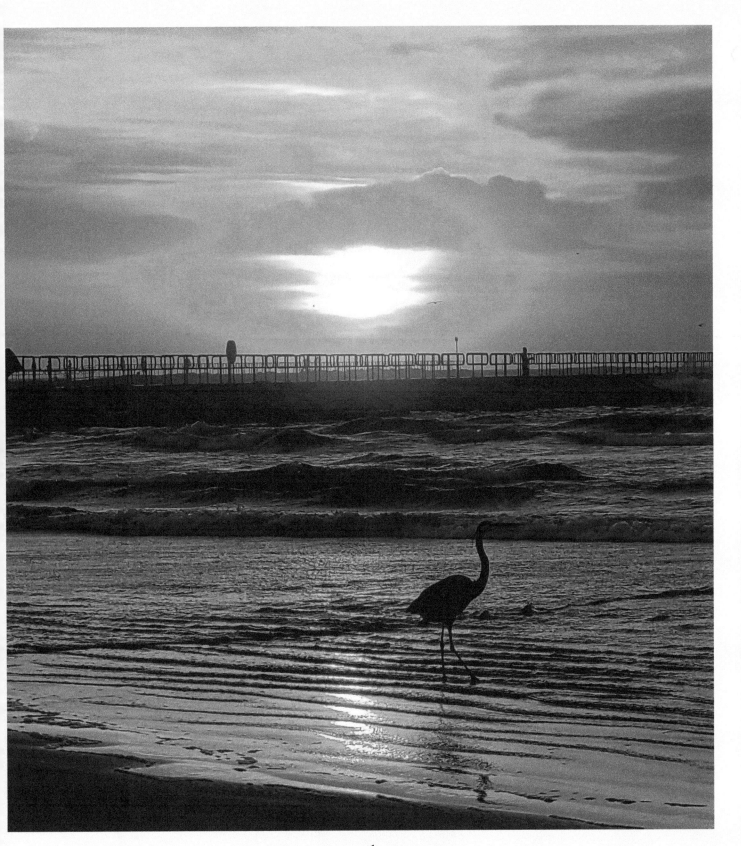

Sunshine

As I walked the beach today,
The sun shone bright into my soul.
Lighting up the darkest way,
Letting the Truth be told!

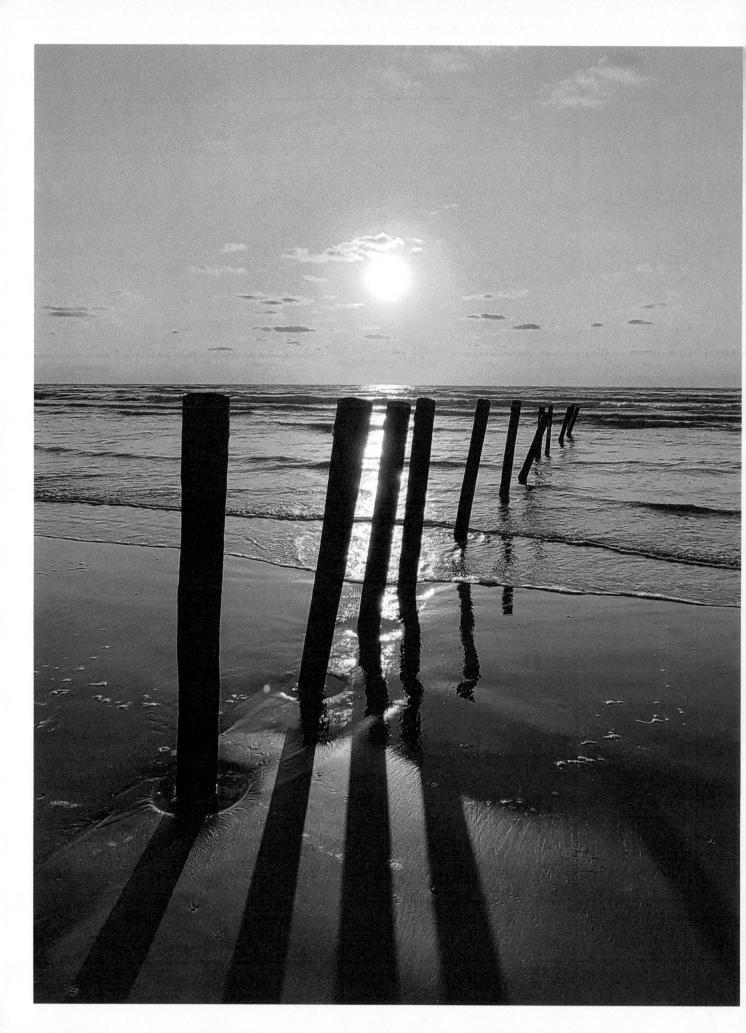

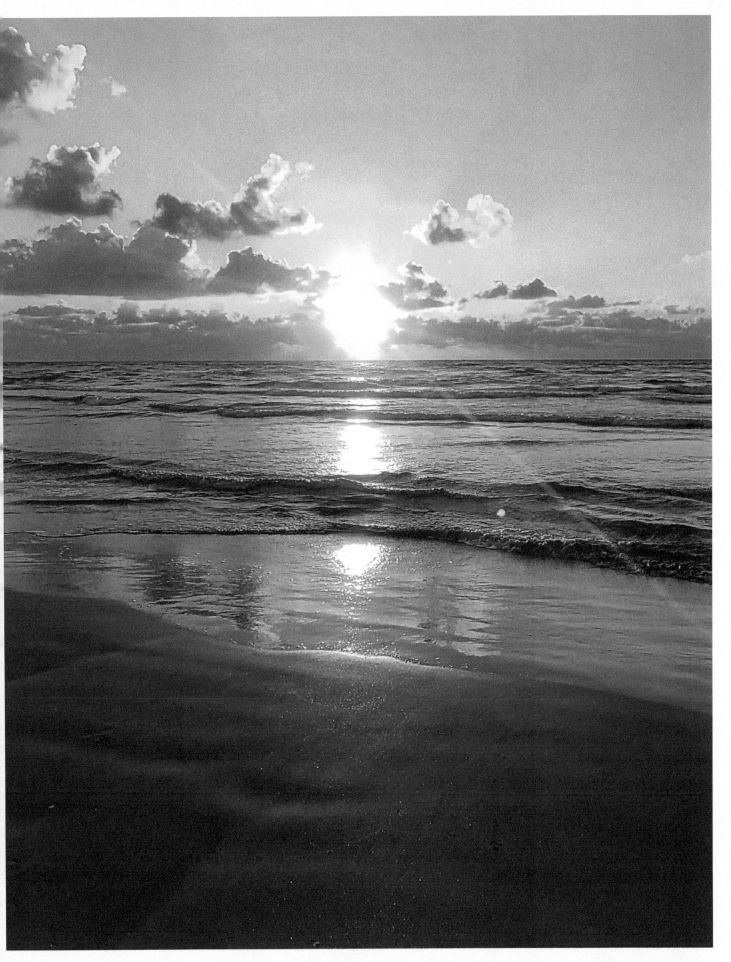

Morning beauty!

Jetties

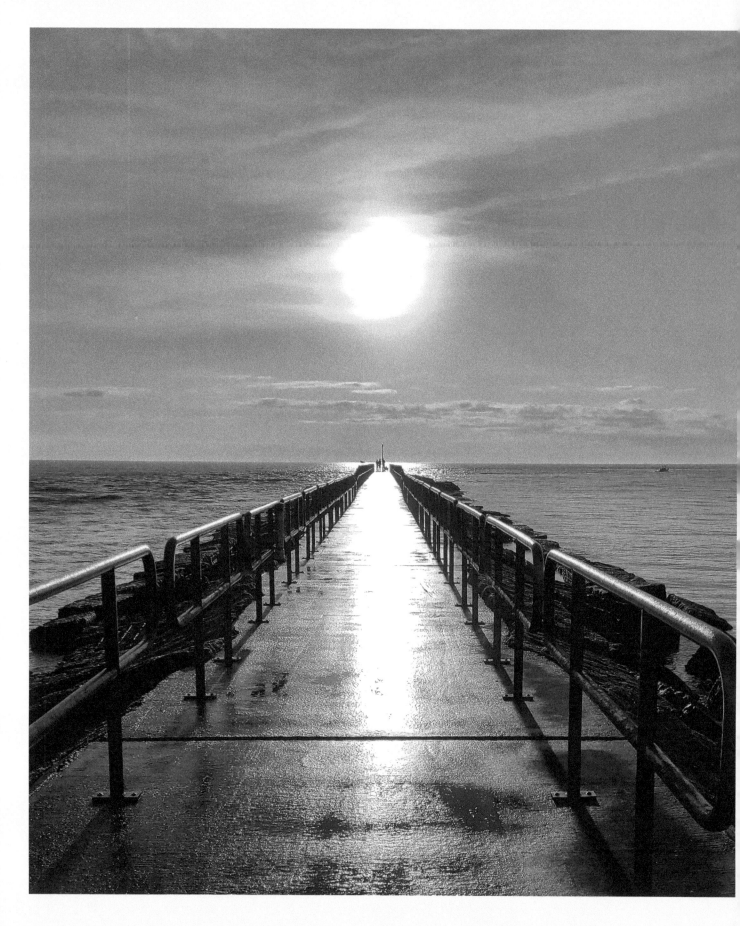

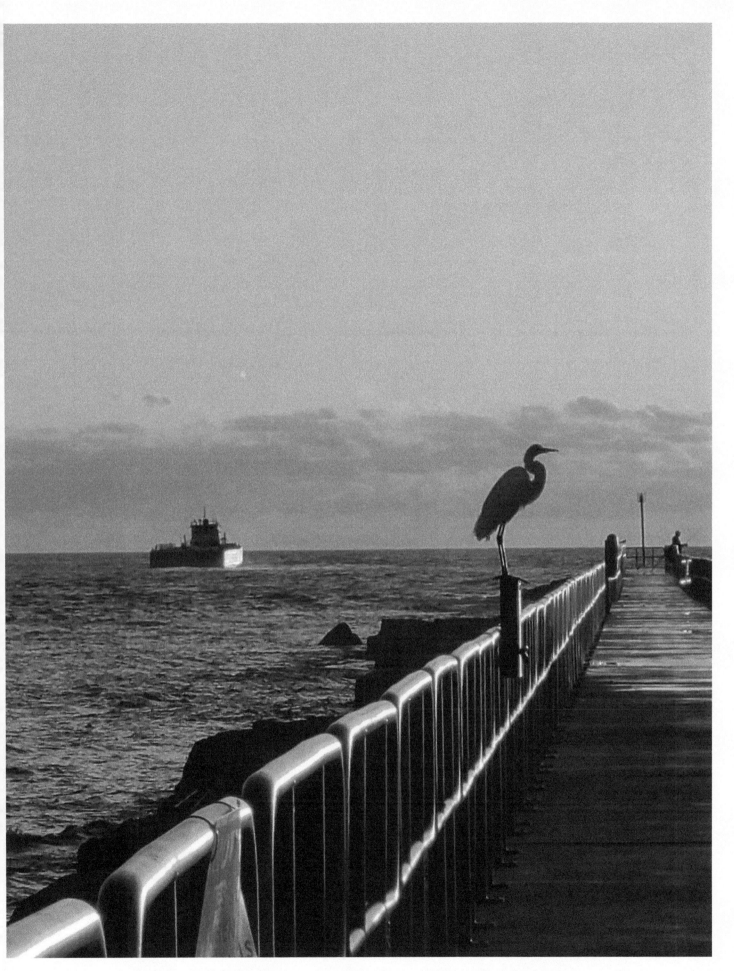

Majestically standing watch over the early morning departure.

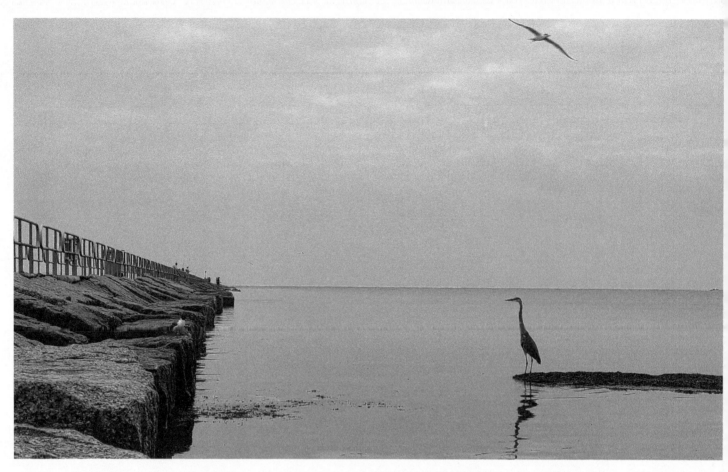

Calm, glass-topped Gulf of Mexico waters rest peacefully alongside the south jetty, allowing the massive granite chunks a time of tranquility.

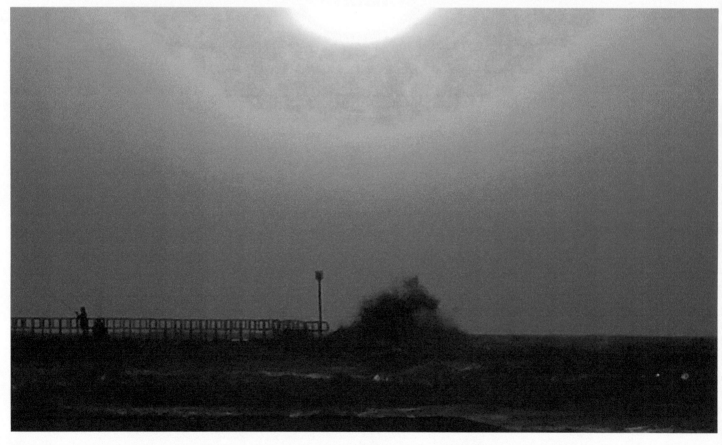

Rough, energetic waters crash into the south jetty, mesmerizing onlookers with a continuous wave show.

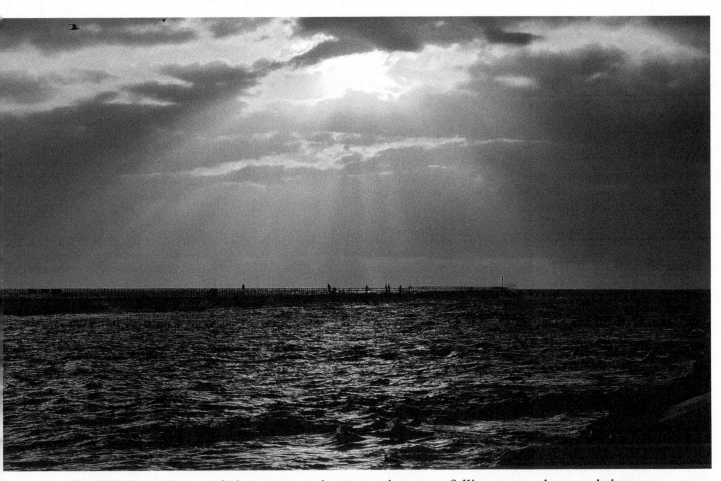

Standing on the south jetty, capturing morning rays falling upon the north jetty.

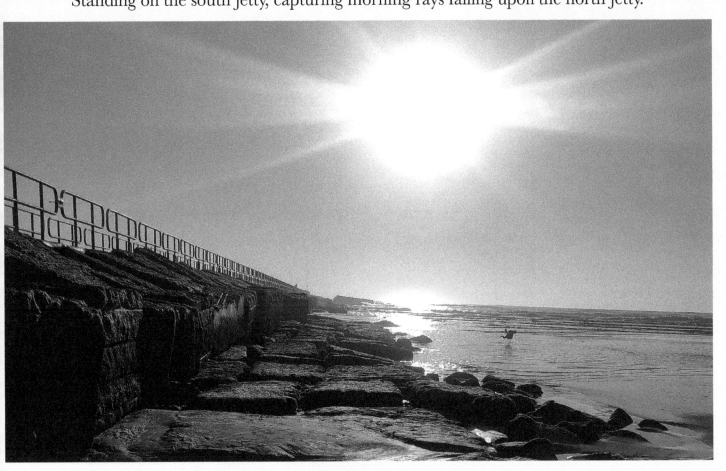

Low tide reveals the massive structure.

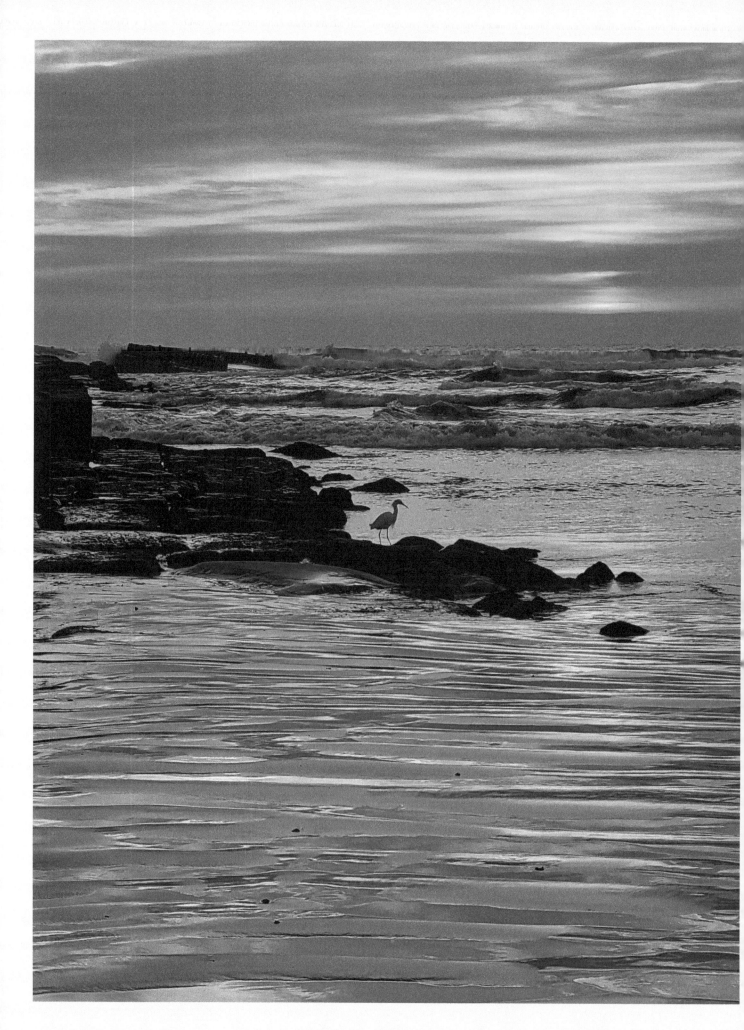

The Barge

As I walked the beach today,
The water retreated off the wall.

Leaving a sandy, watery way,
But I carried on.

I had to get closer so I could see
What that object is nestled against the jetty.

Sun rising, shining large.
Oh my! It's a barge!

Hurricane Ian's waves reached across the Gulf and won the fight,
Setting her free and into her plight!

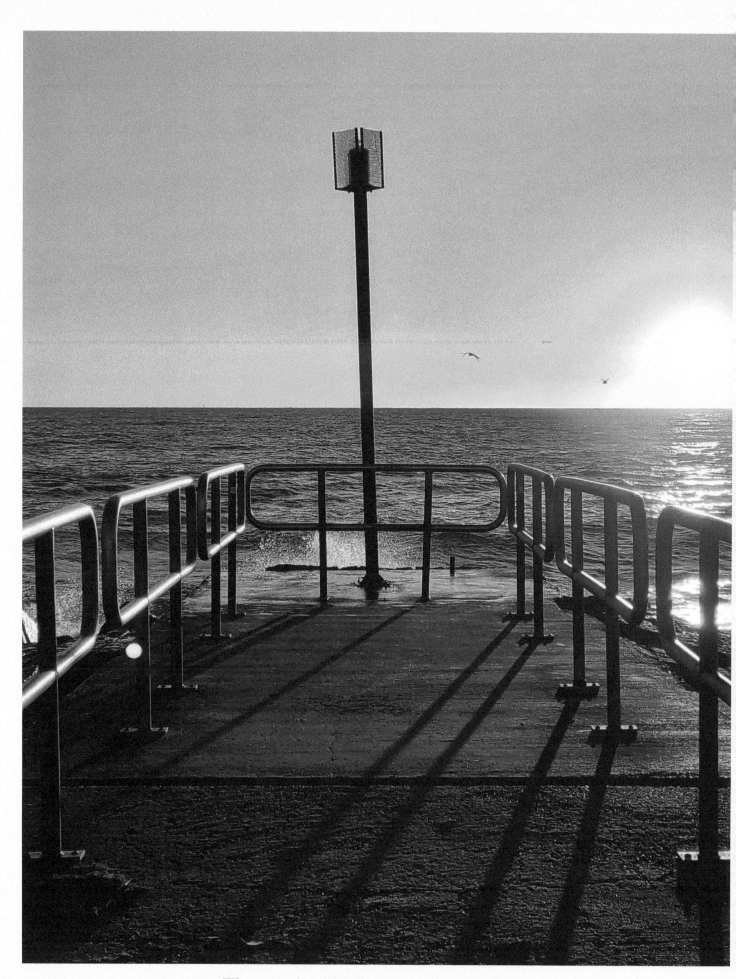

The morning light greeting the night light!

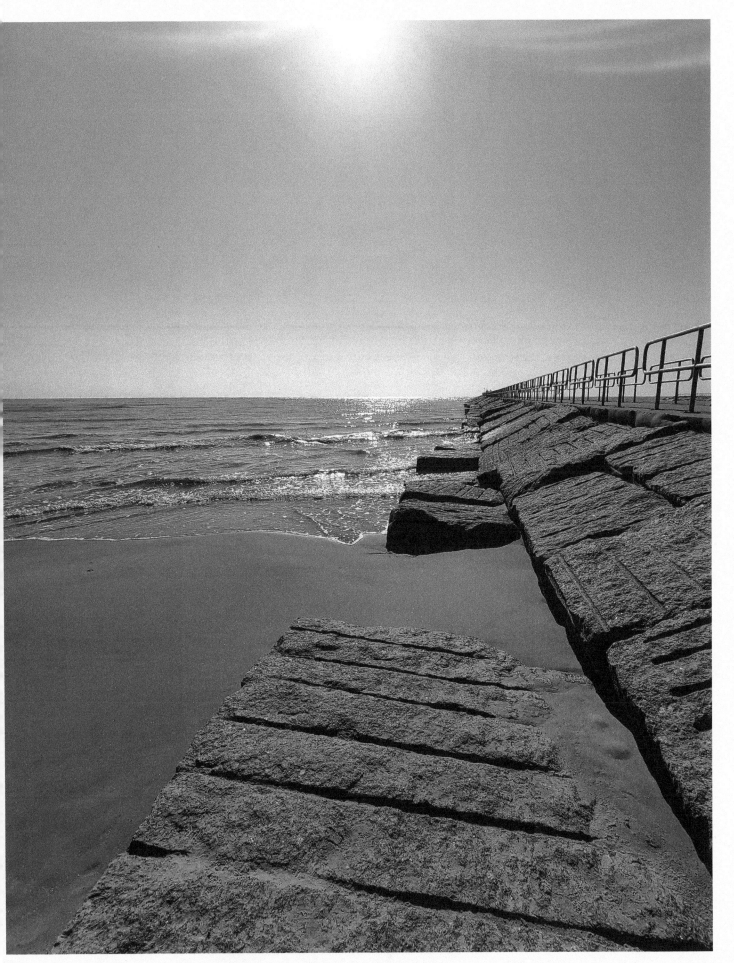

The north jetty!

Bob Hall Pier

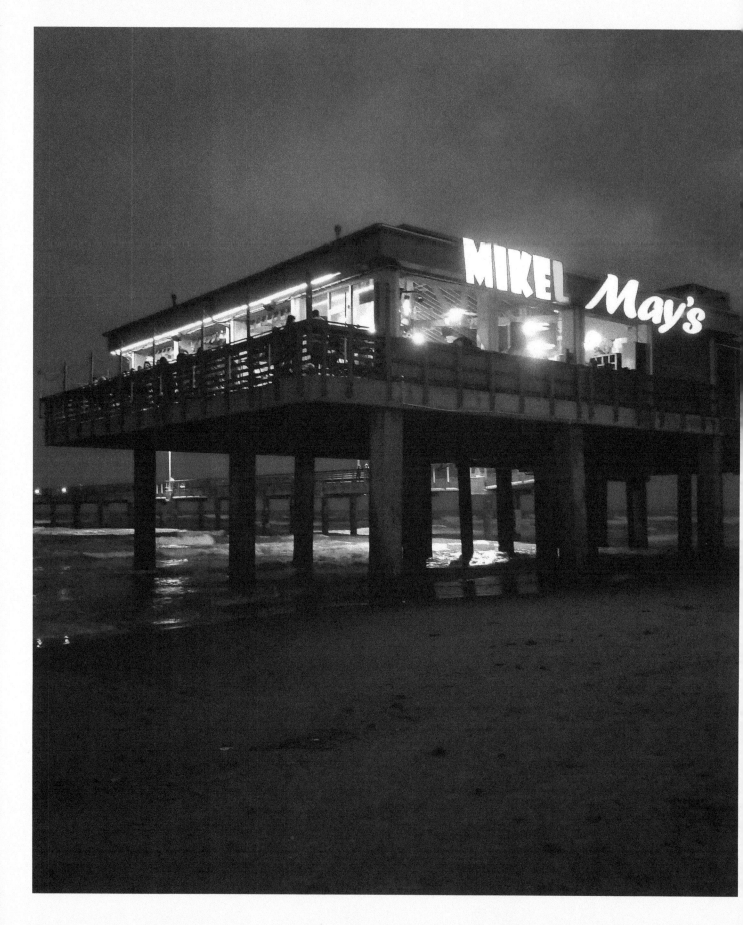

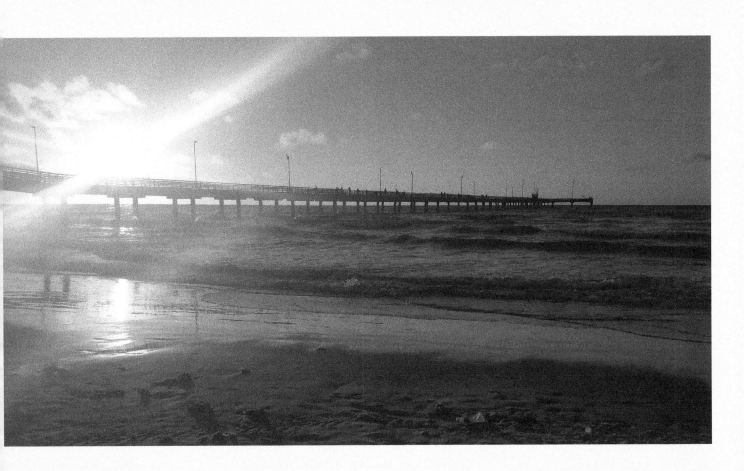

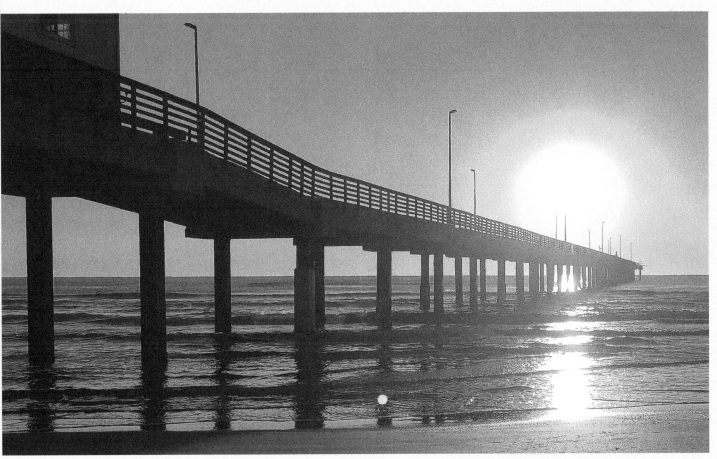

Morning sunbeams illuminate Bob Hall Pier standing watch over Whitecap Beach. Damage resulting from Hurricane Hannah has led to deconstruction of the pier pictured here. Islanders anxiously await the new construction to begin.

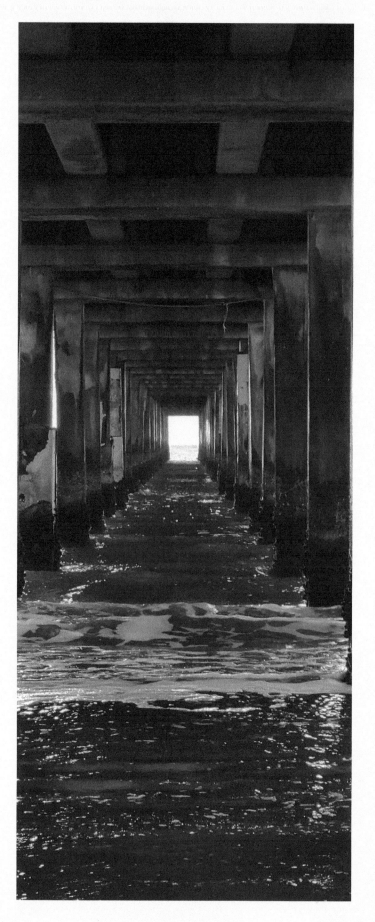

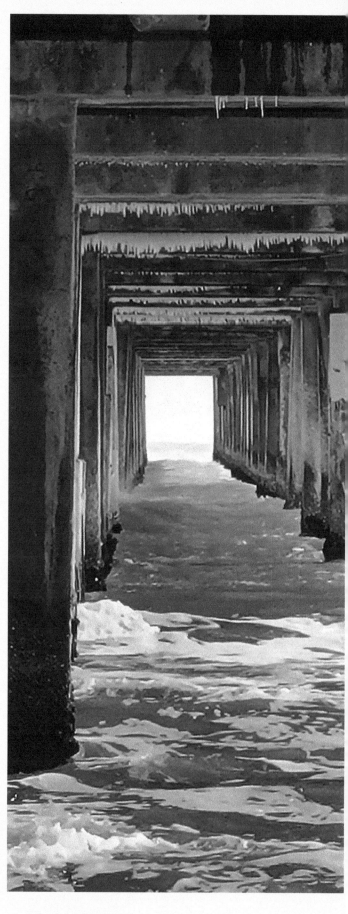

My personal favorite—morning
views from under the pier.

Rare icicles formed on Bob Hall Pier's
understructure—February 2021,
the Great Texas Freeze

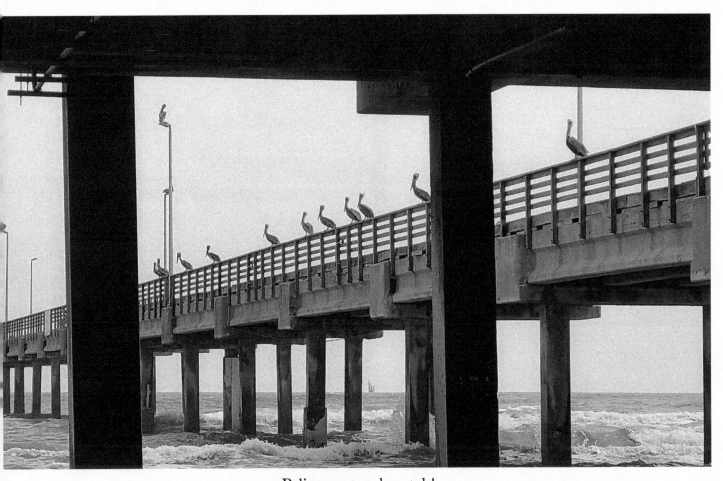

Pelicans stand watch!

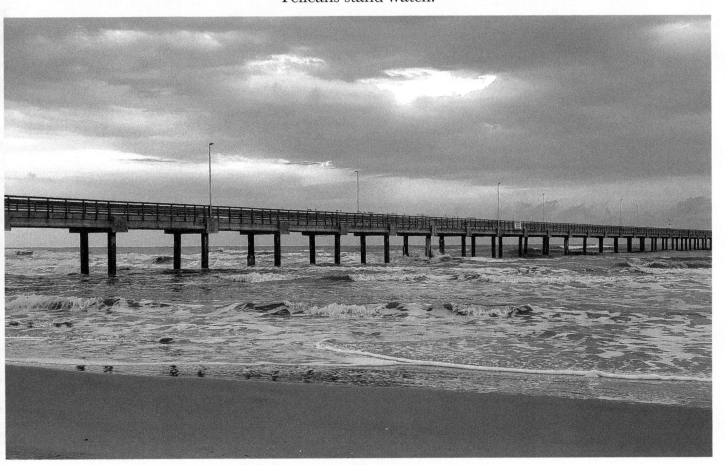

Storms a-comin'!

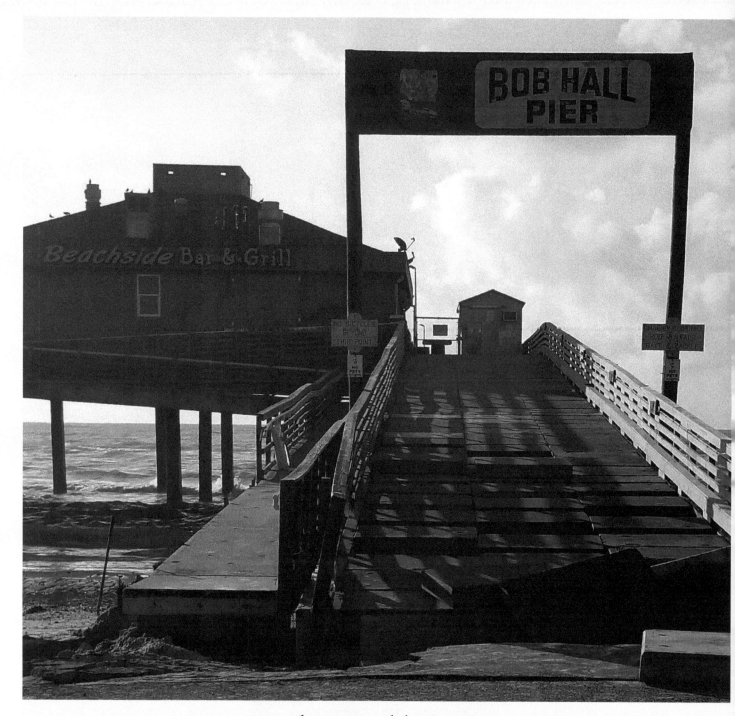

Bob Hall Pier

As I walked the beach today,
Bob Hall Pier completely gone.
The last few months—fading away,
Making room for the new one.

Similar to life,
Destruction needed—tearing down to the core,
Rising up,
Construction new—Better than before!

30

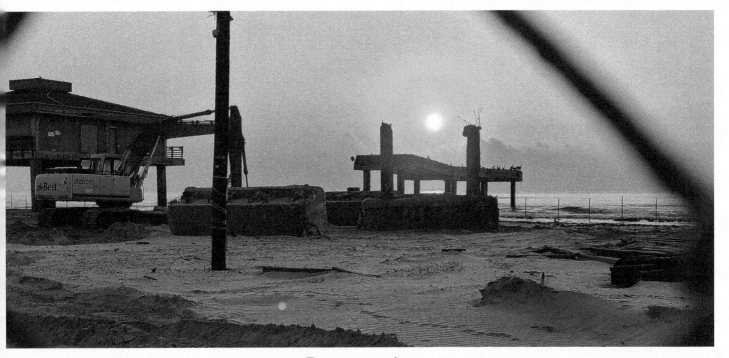

Deconstruction

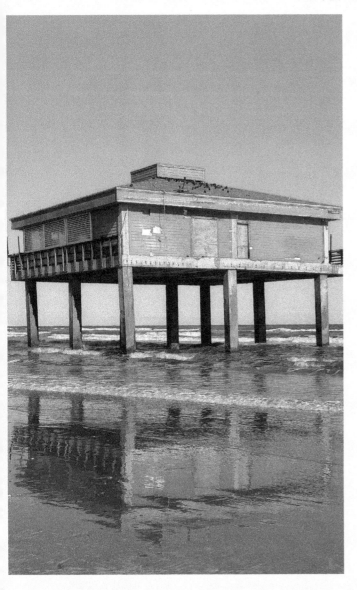

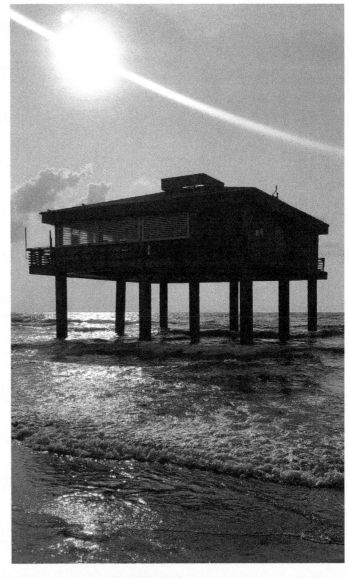

Awaiting the new…

Fog and Haze

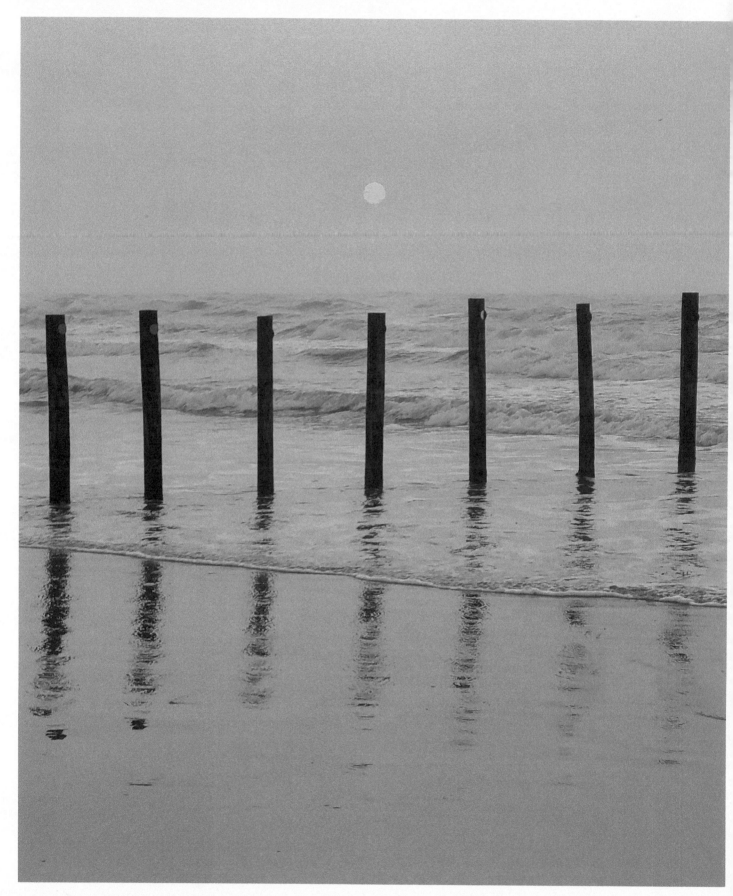

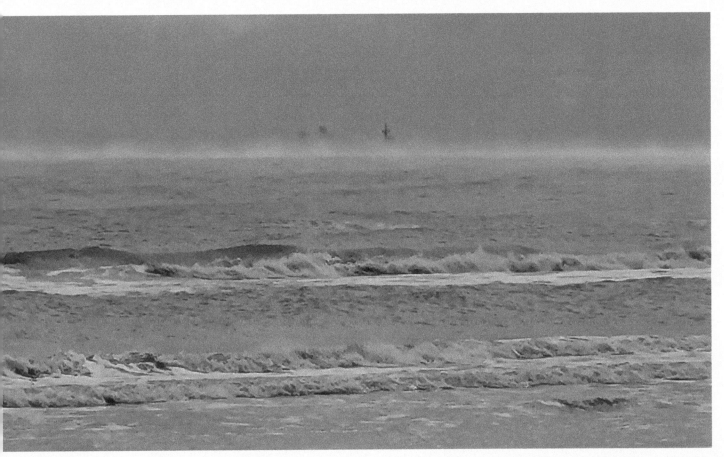

Looking offshore through the winter steam caused by the Great Texas Freeze, February 2021. Wells in the Gulf stand almost hidden on a cold, frozen day.

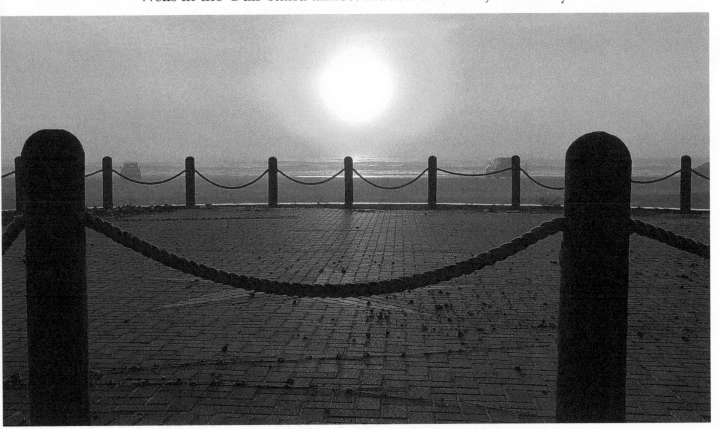

Haze dulls the golden glow captured while walking the circle drive where the pavement ends, before stepping onto the sand at Whitecap Beach.

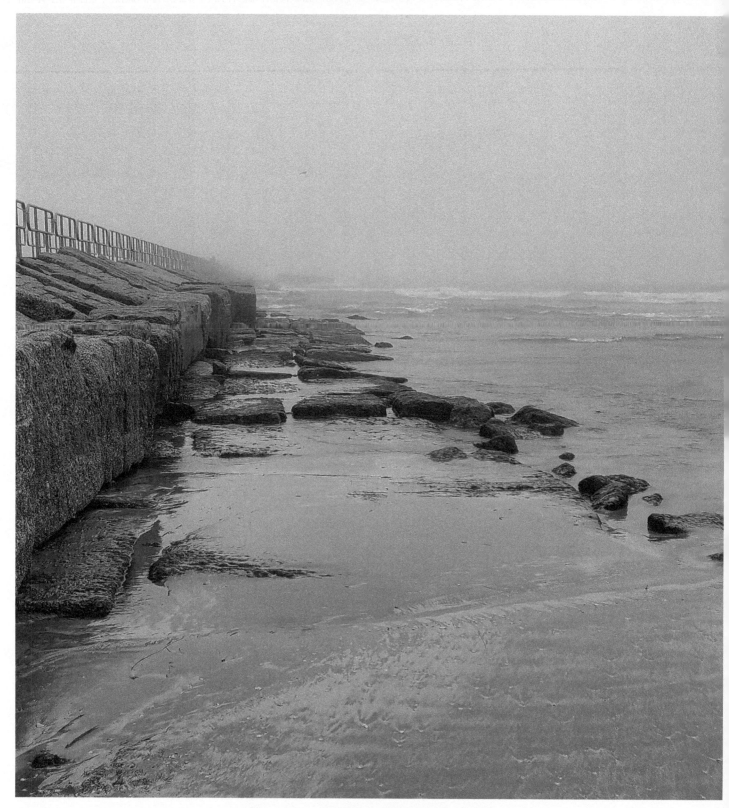

Fog Snuggles

As I walked the beach today,
The fog snuggled in around the dunes.
The tide pushed back
A few small waves.
My gratitude whispered to you!

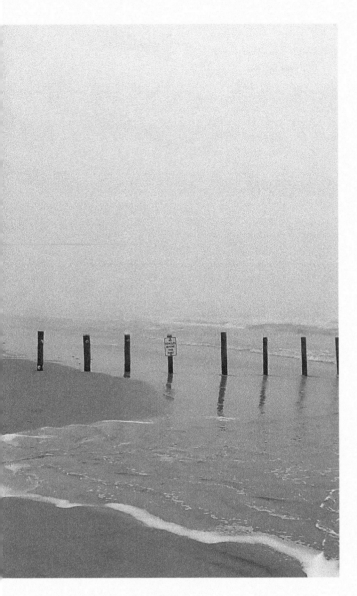

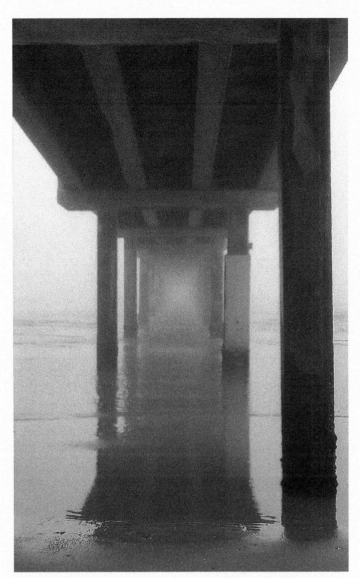

Fog creeps in under Bob Hall Pier!

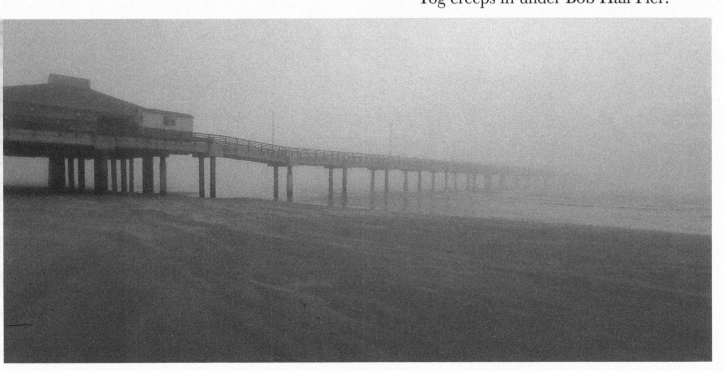

Pier through the fog!

Dunes

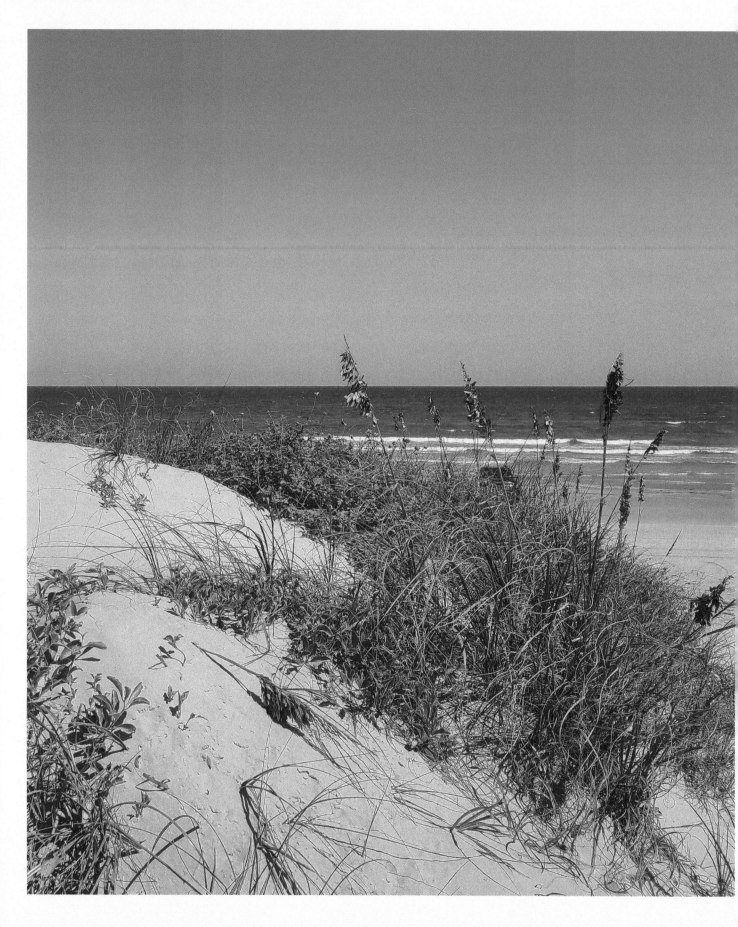

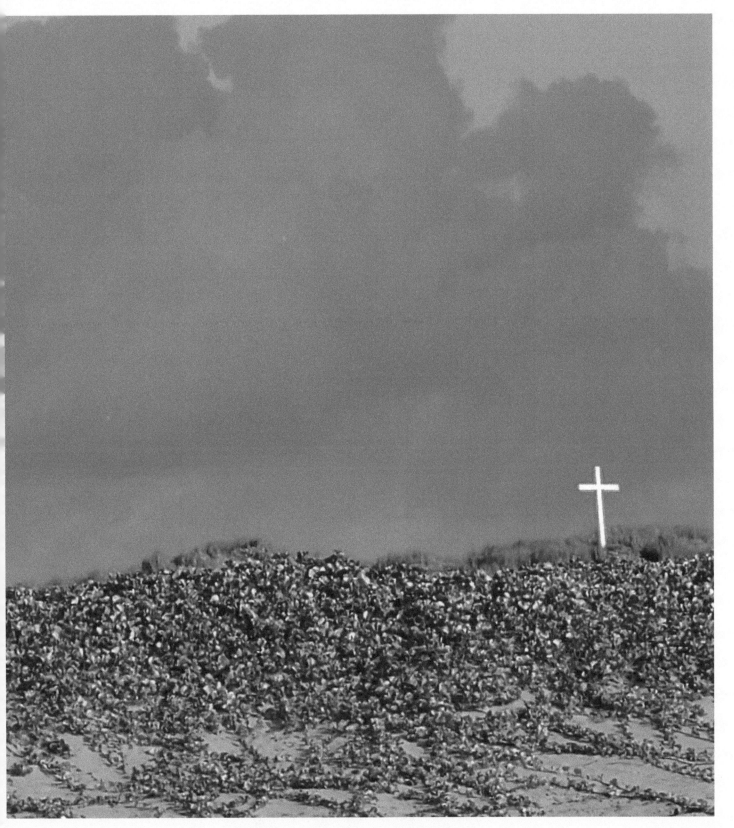

Prayer Walk

As I walked the beach today,
I whispered a prayer just for you
To still the rolling turmoil inside,
Allowing your value and worth to shine through.

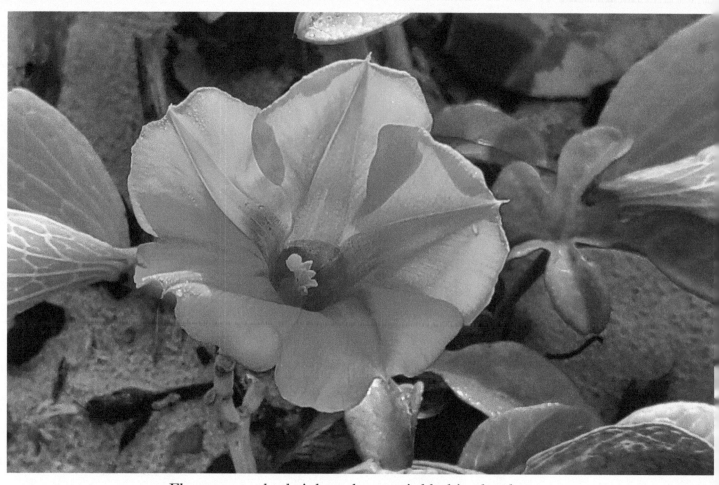

Flowers are the bright colors sprinkled in the dunes.

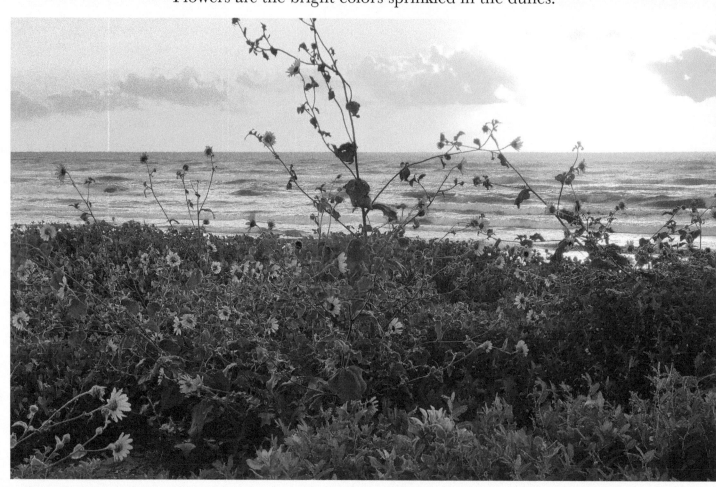

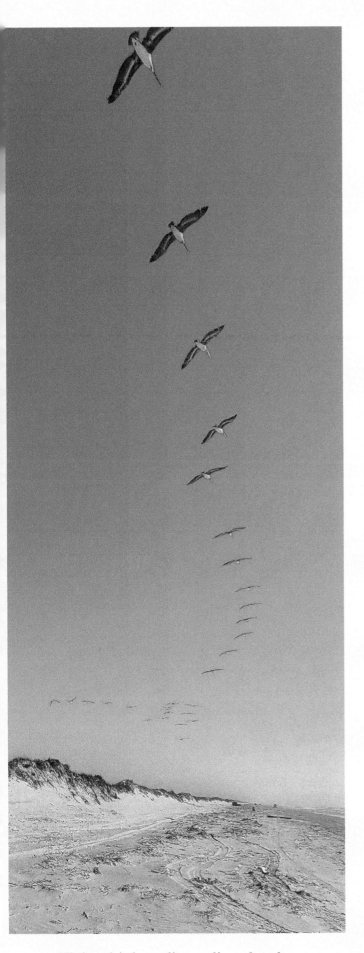

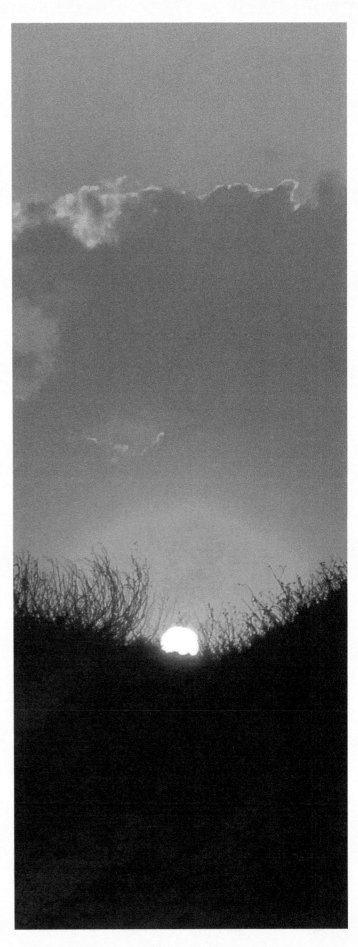

Flying high, pelicans line the sky.

Long, hot Texas days find the shining sun settling behind the Whitecap dunes. Good night!

Treasures on the Beach

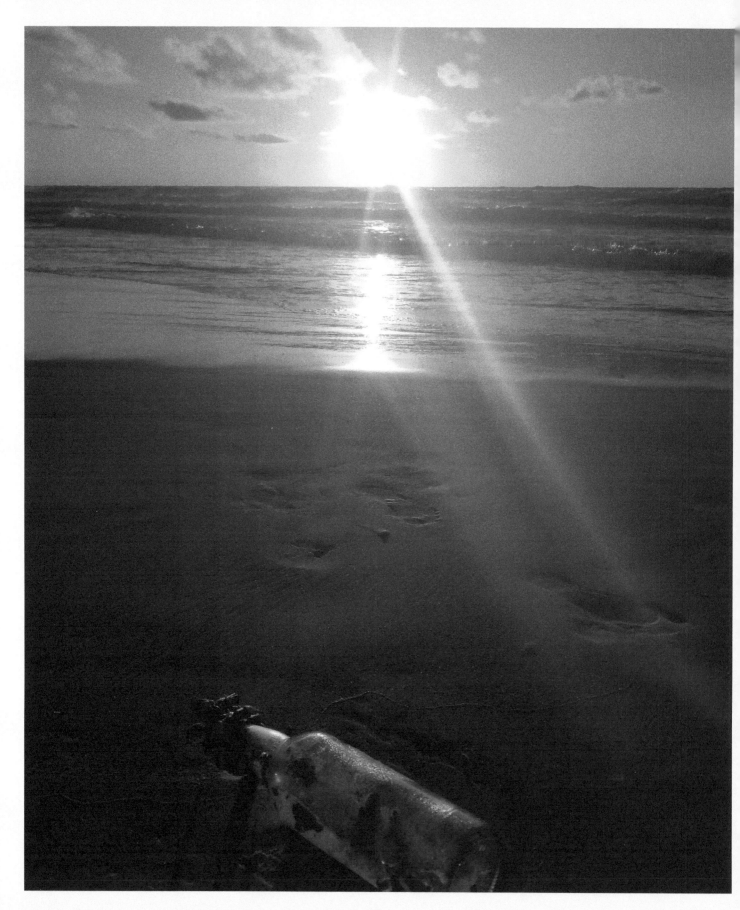

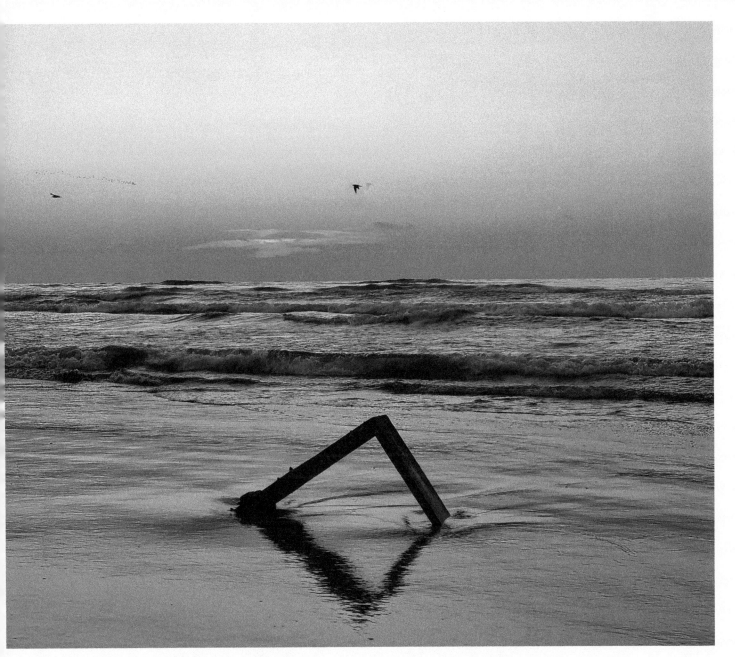

Childlike Excitement

As I walked the beach today,
The sun hidden behind the clouds,

I encountered a lady along the way,
Mesmerized with barnacles reaching out.

Chattering with excitement to all those passing by,
Pointing out her discovery, bringing the sparkle to her eye.

Walking over to me and back again, where the little wooden box lay,
Saying it reminded her of the song in that show—Disney's *The Little Mermaid!*

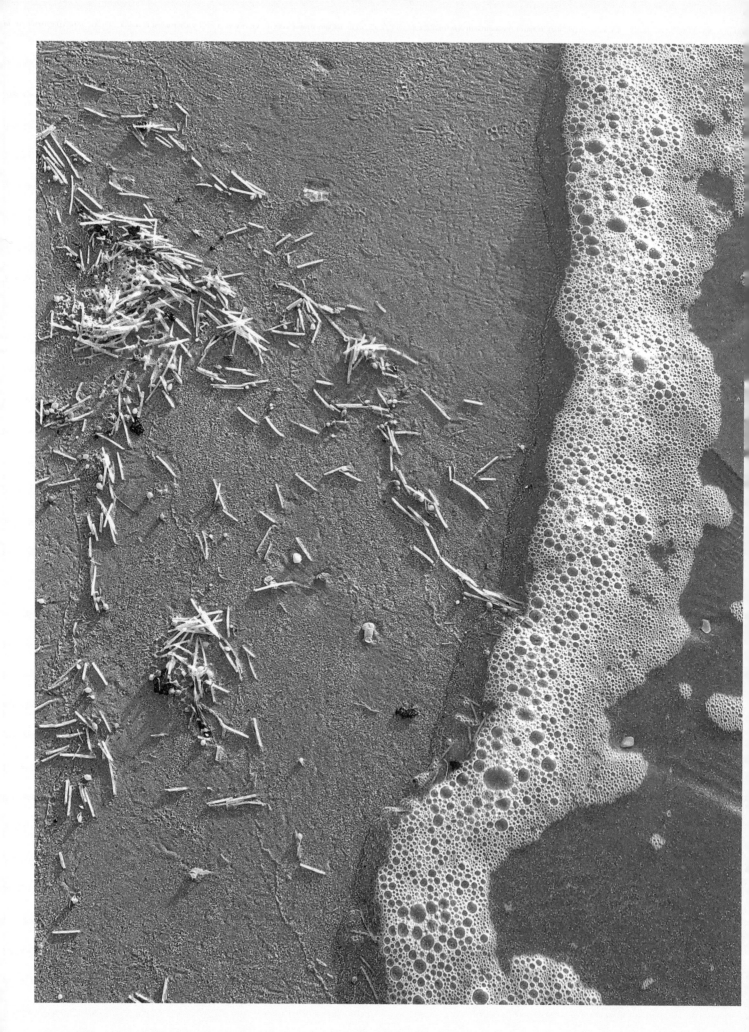

Jellyfish Hair

As we walked the beach today,
My granddaughter chattered the whole way.

Squawking along, Talking to the birds.
The gulls responded—They know her words.

Dead fish and worms and turtle fun
Strolling along, enjoying the sun

Splashing in puddles and water waves
She looked down at her foot and raved
"Oh! There's a jellyfish hair on my toe!"
"Jellyfish have hair? I didn't know!"

I love our adventures we have.
Life doesn't get better than that!

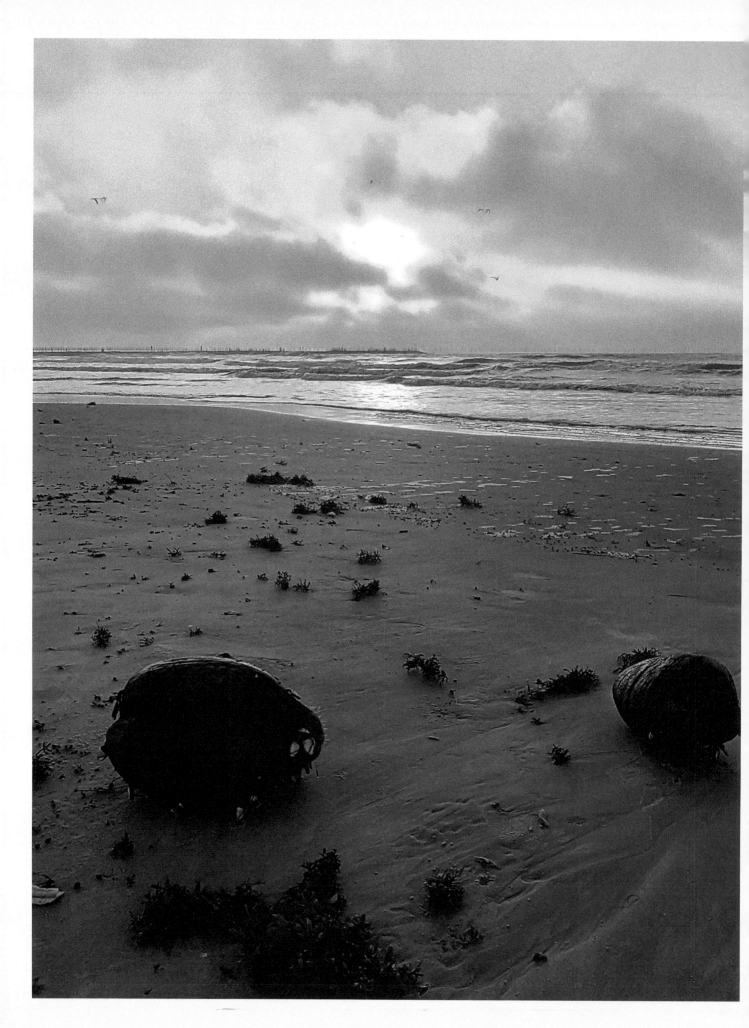

Coconut Hands

As I walked the beach today,
My granddaughter and me the whole way.

The flowers "prettiful" and sun perfect for us!
Round the bollards and back—adventurous.

Coconuts with hands,
Plastics too.
Baby man-o'-wars,
So much to see—ooh!

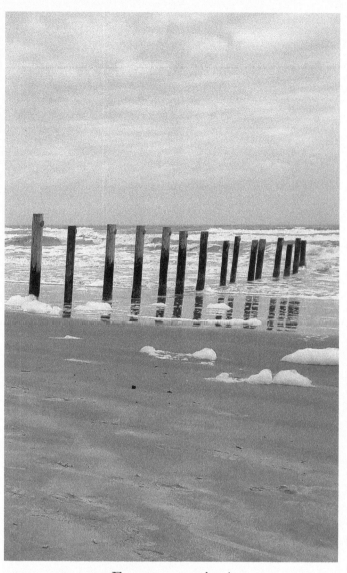

Foamy morning!

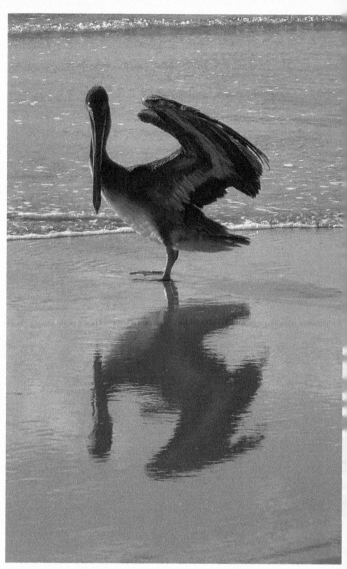

Pelican admiring his reflection!

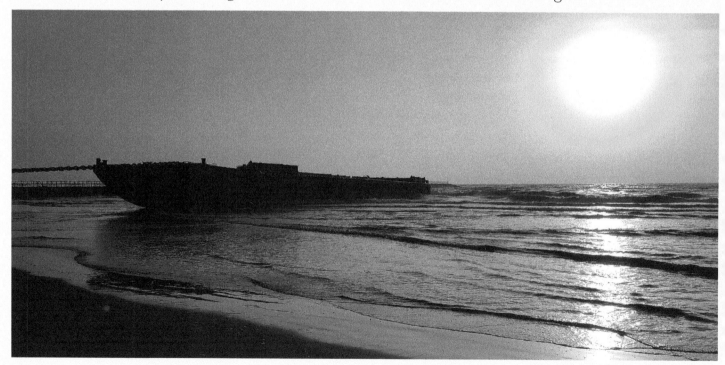

Beached barge—south jetty in the background

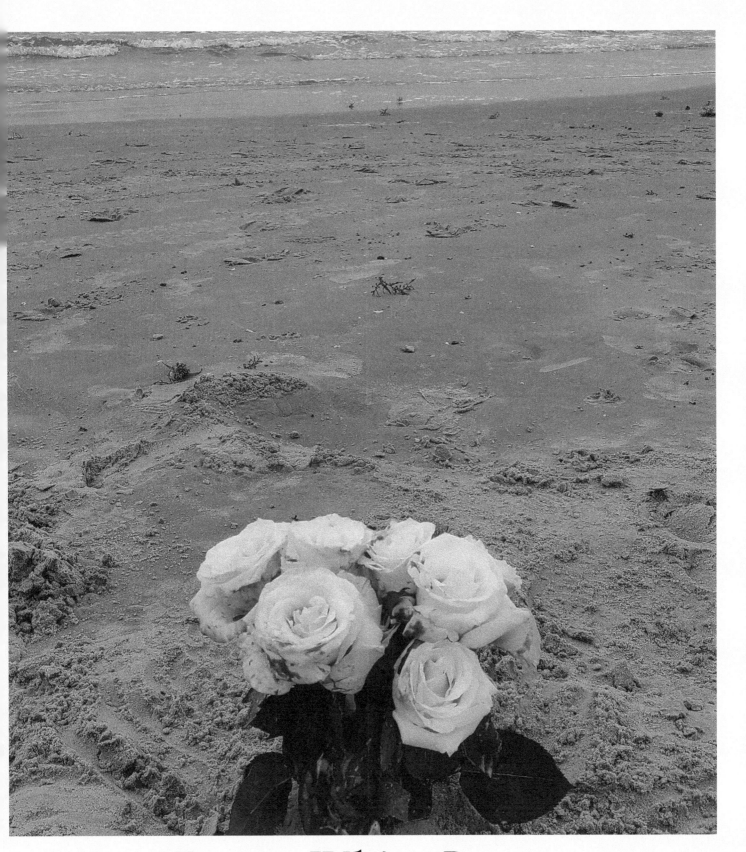

Easter White Roses

As I walked the beach today,
You met me there with a beautiful surprise.
I gathered the flowers into a white bouquet.
Gratefulness and love brought tears to my eyes.

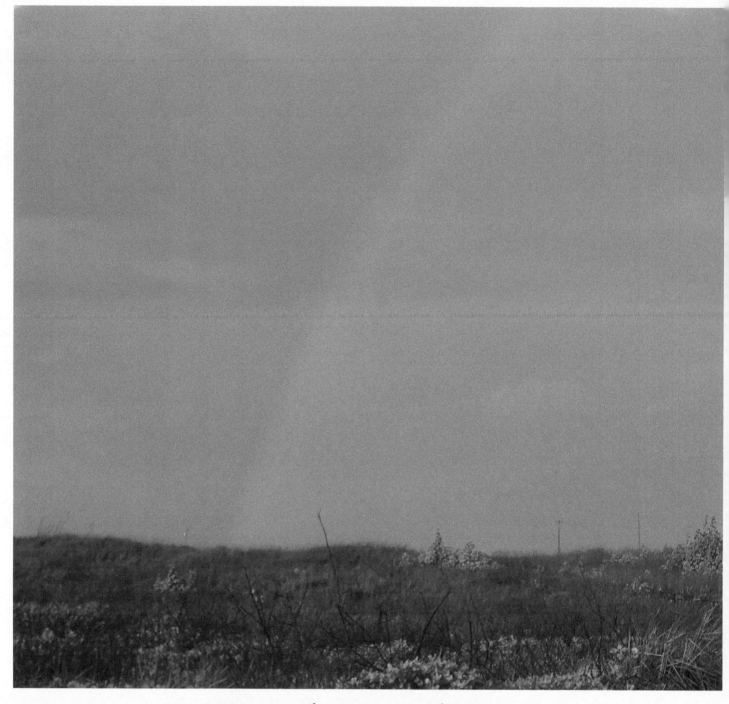

Beach Rainbow

As I walked the beach today,
A rainbow was pointed out along my way.
Turning around the colors—vivid and bright,
Reminded me of God's long-ago promise—a beautiful sight!

The foam-kissed salt water washed over my toes.
The shimmering ice-blue water, that's my favorite, you know.
Breathing sea air deep into my chest,
Calming my thoughts, putting my mind at rest!

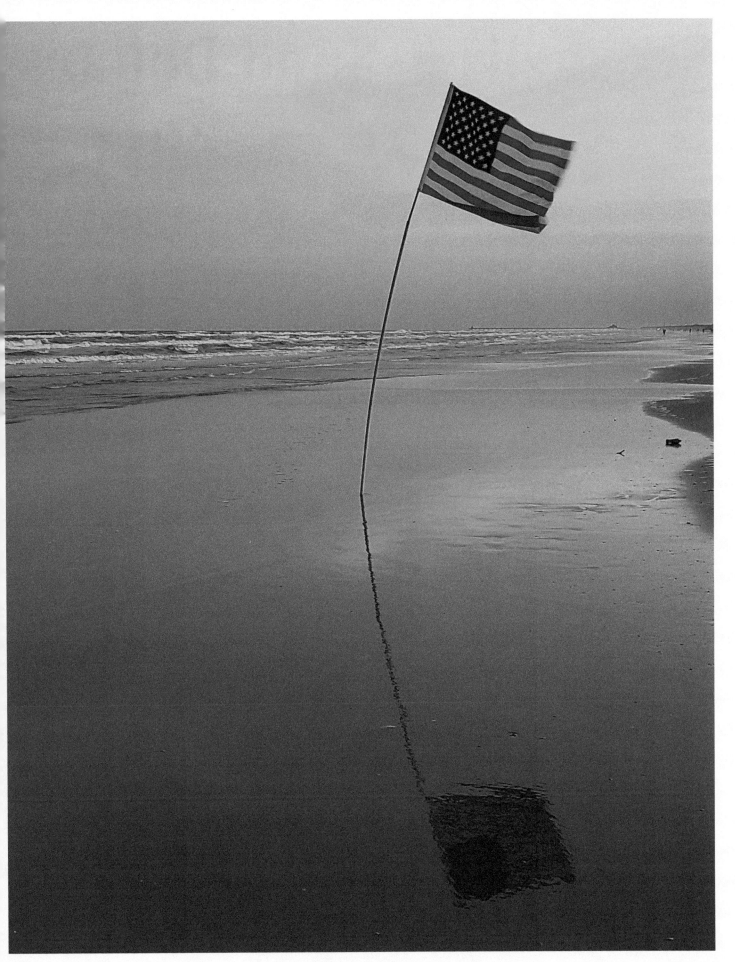

Independence Day!

Seashells & Sand Dollars

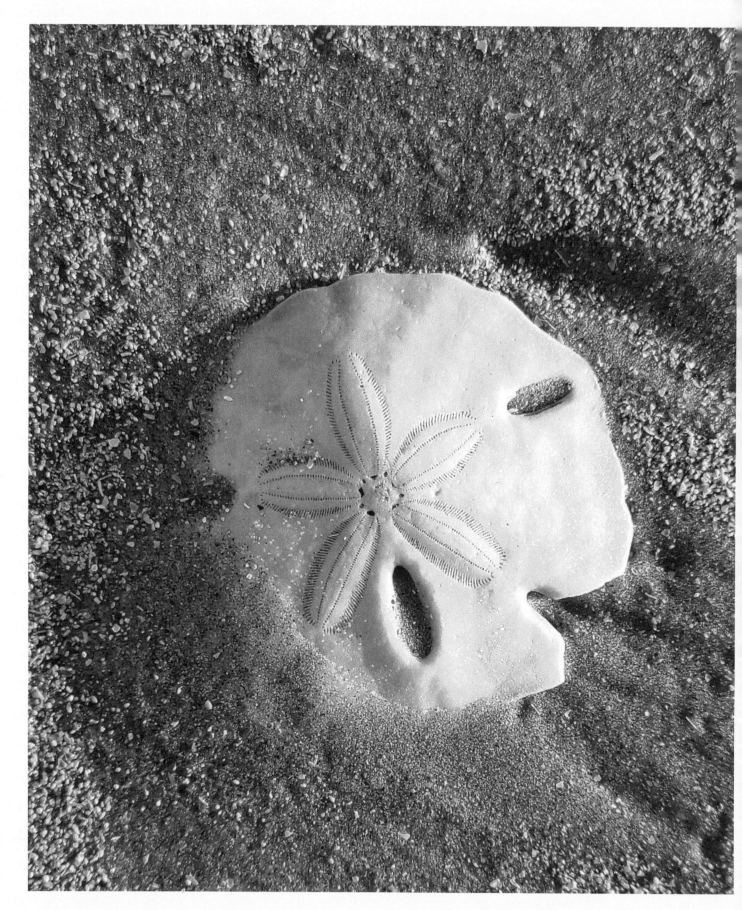

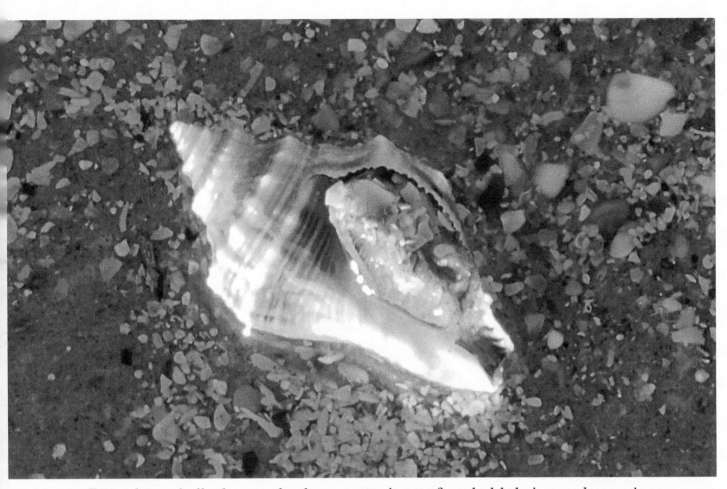

Even those shells that are broken, not quite perfect, hold their own beauty!

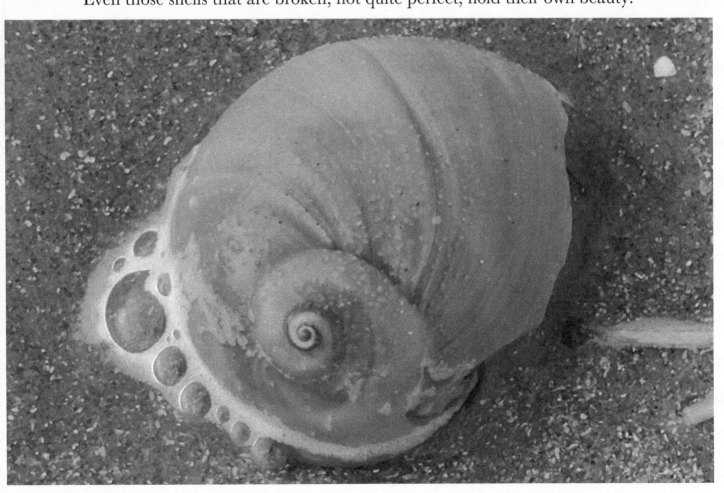

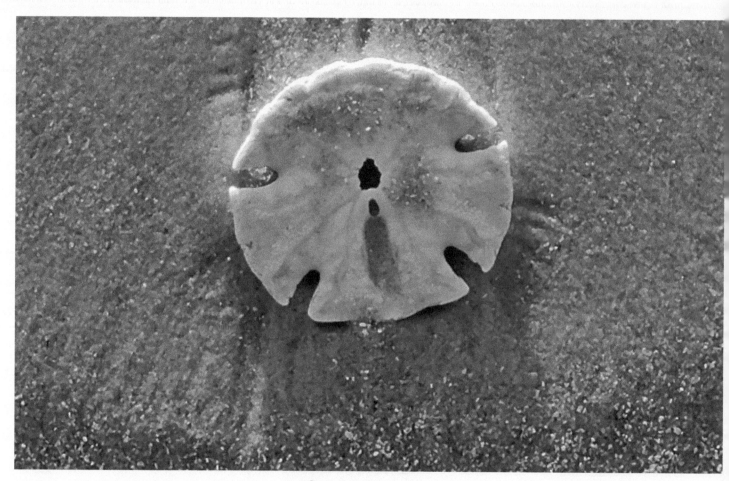

Sand dollars aka

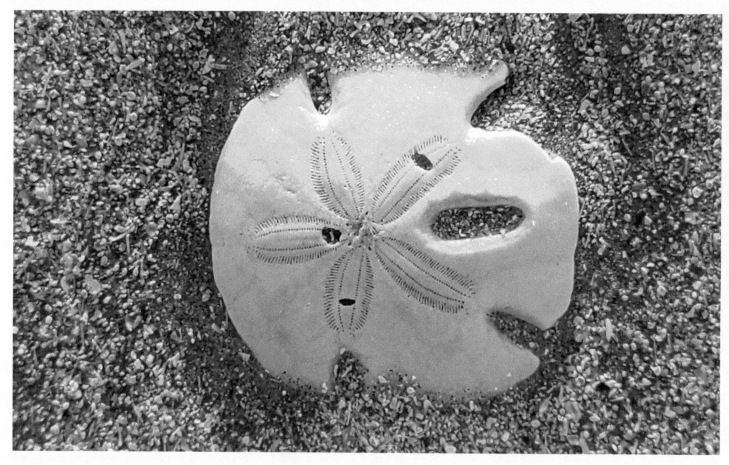

Mermaid Money. Sea Money. Wealth of the Water

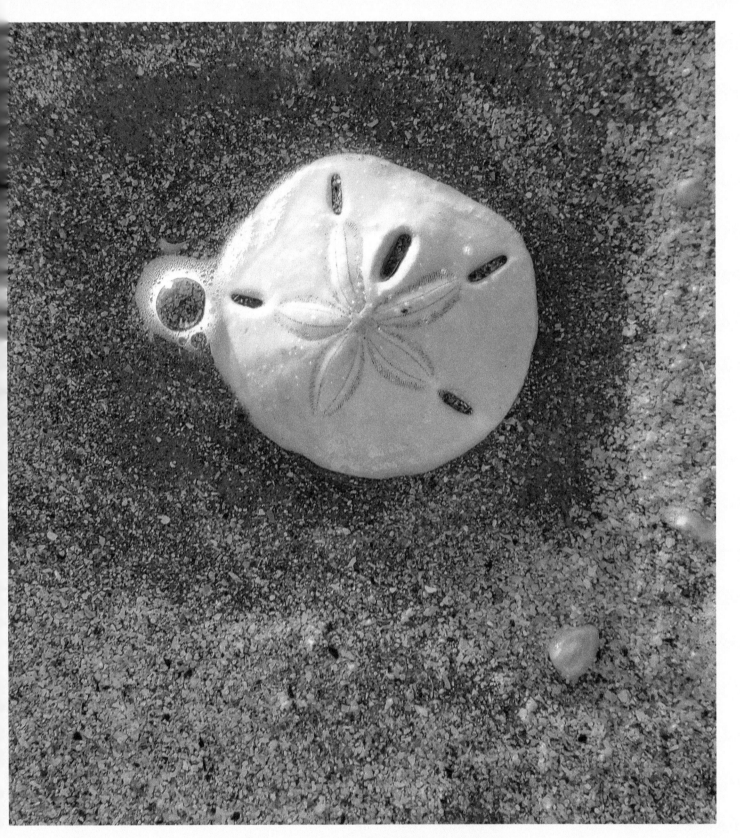

Sharing Shells

As I walked along the beach today,
I found a shell just for you.
When we met, I freely gave.
A piece of my heart went with it too!

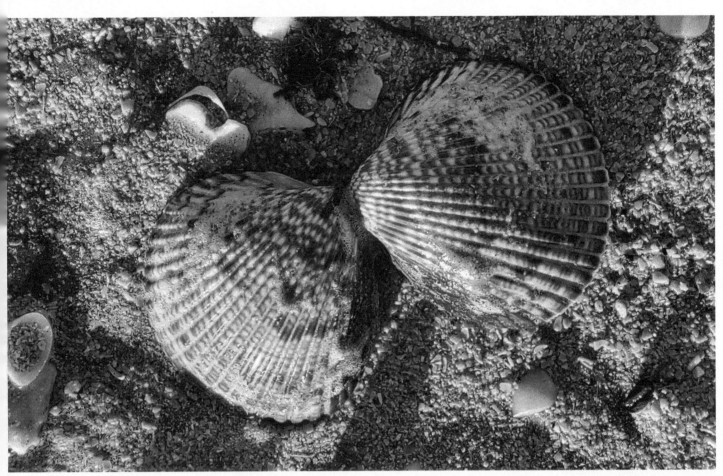

Bivalve shells—equal sides connected by a hinge. The coveted find, "still attached"!

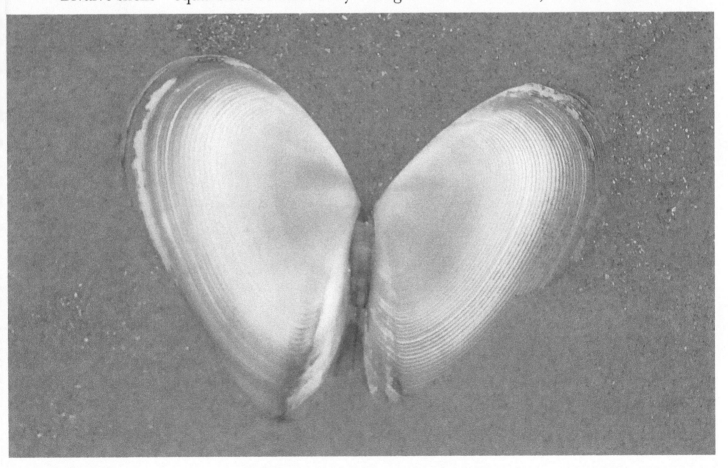

The pink butterfly

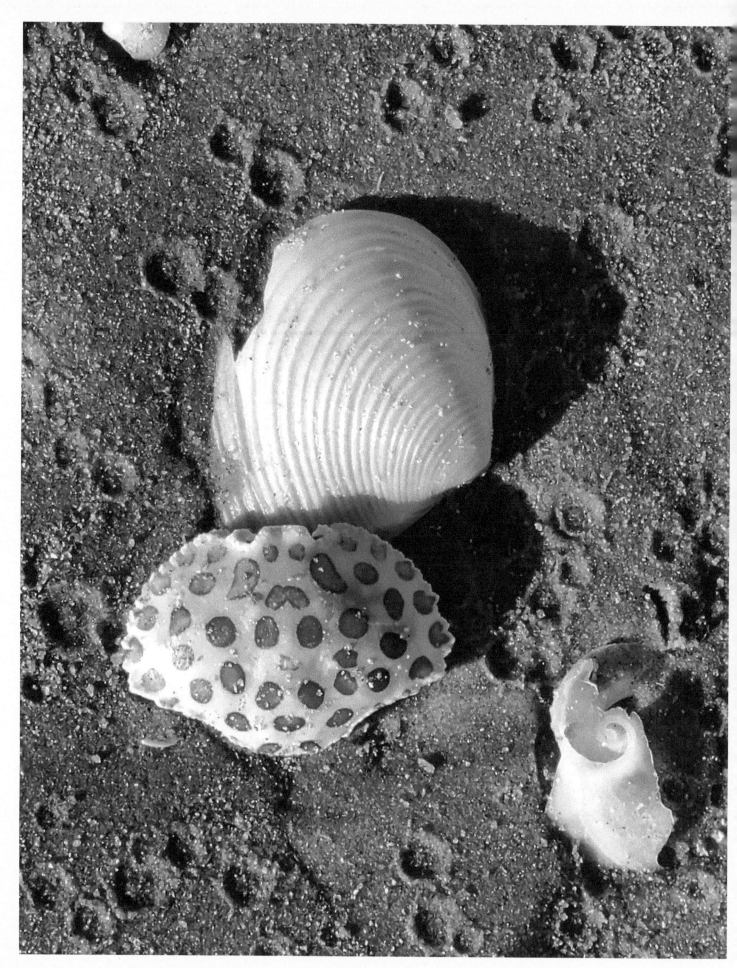

The deceiving spotted-crab shell!

Healing and love can be found amidst the brokenness.

Sea Creatures

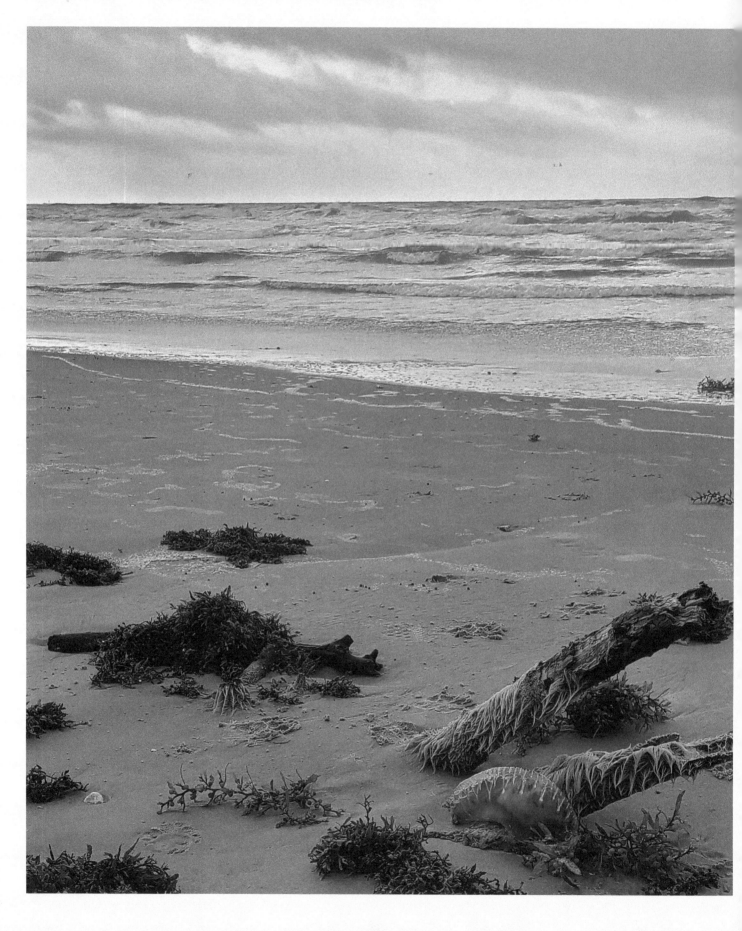

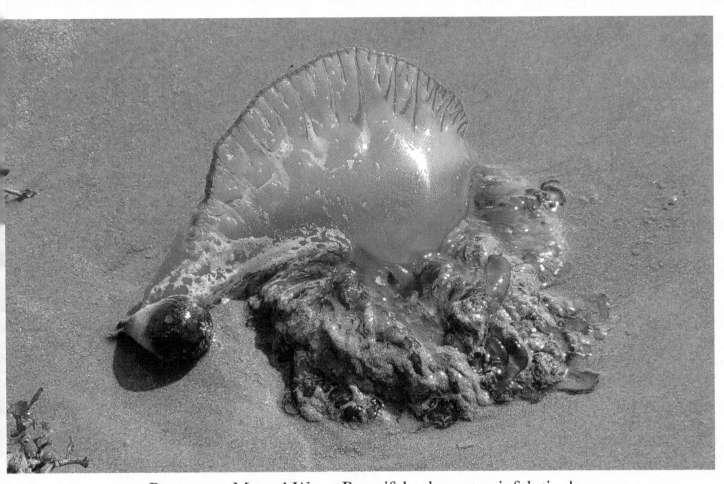

Portuguese Man-o'-War—Beautiful color, yet painful sting!

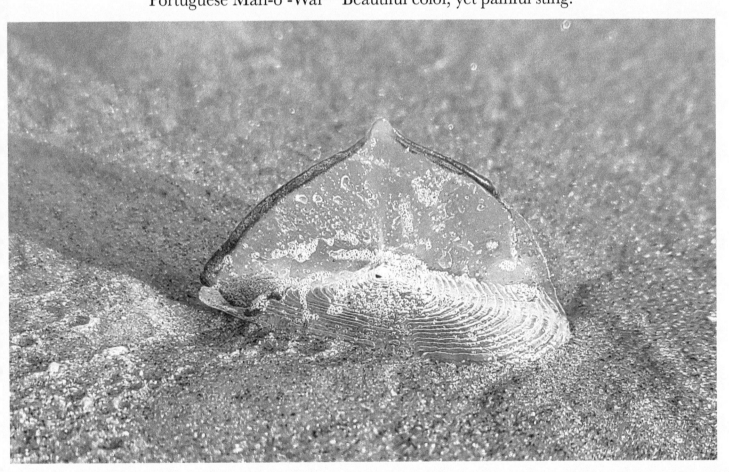

By-the-Wind Sailor washed onshore!

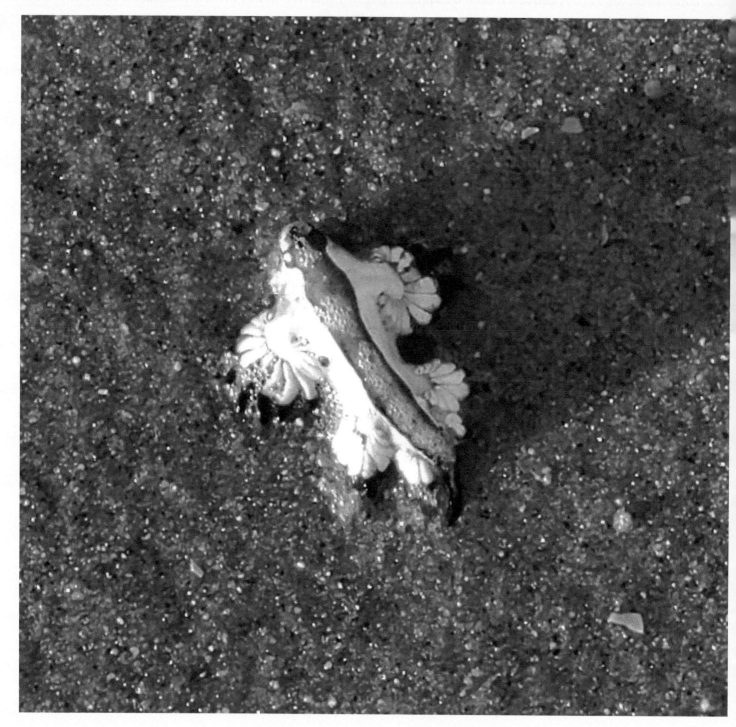

Blue Dragon

As I walked the beach today,
We finally met along the way.

Three years I've searched the oceanside…far and near,
And today…I find you lying right here.

Teeny, tiny, smaller than my little toenail—I hear your sting really packs a punch
You're called a Blue Dragon sea slug; with blue and white colors, looking pretty a bunch!

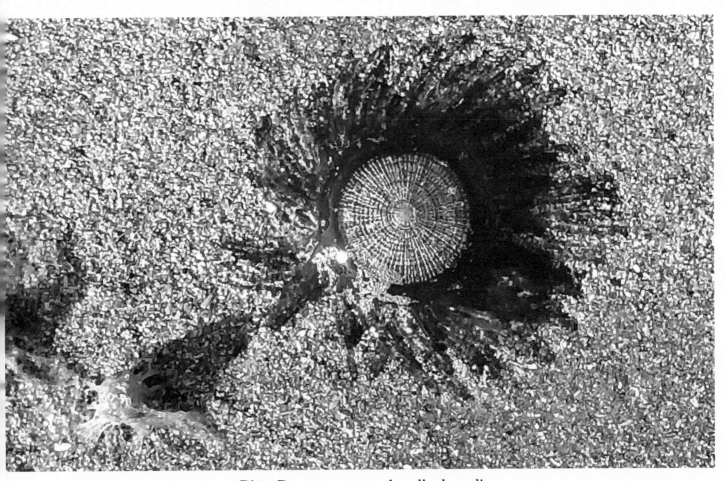

Blue Button—tentacles displayed!

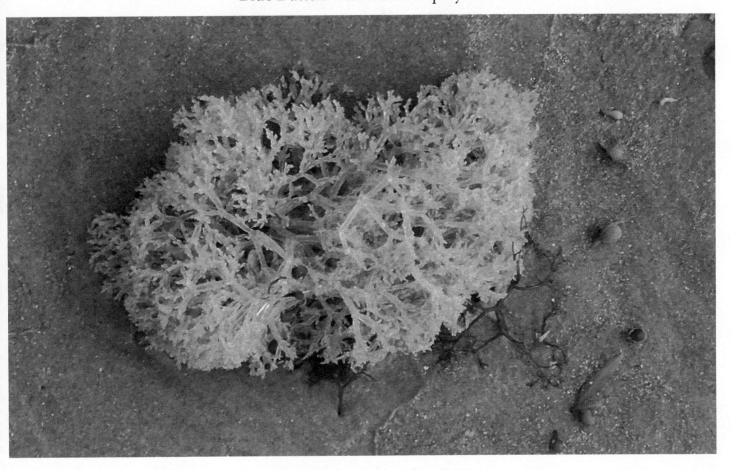

Sponge—soaking it up!

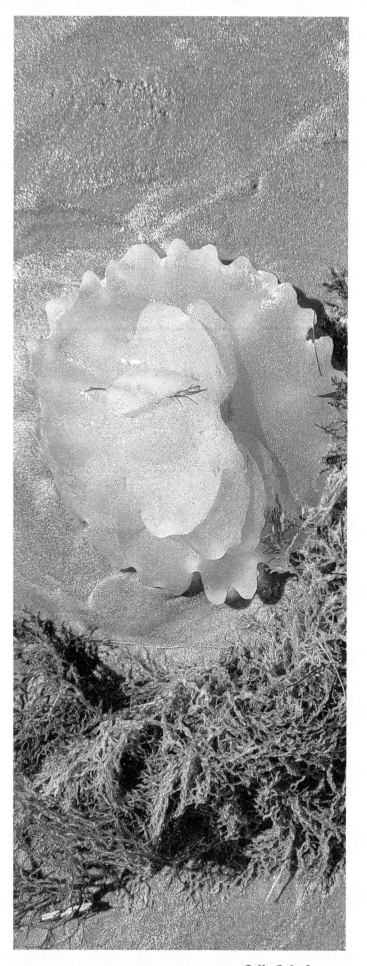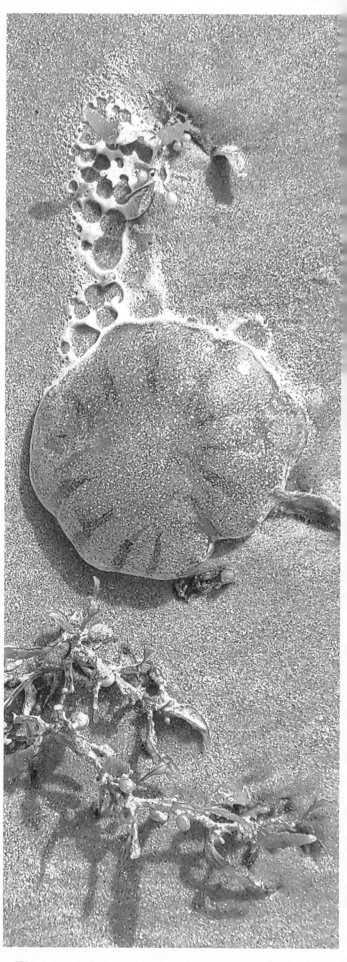

Jellyfish frequent the Texas sands.

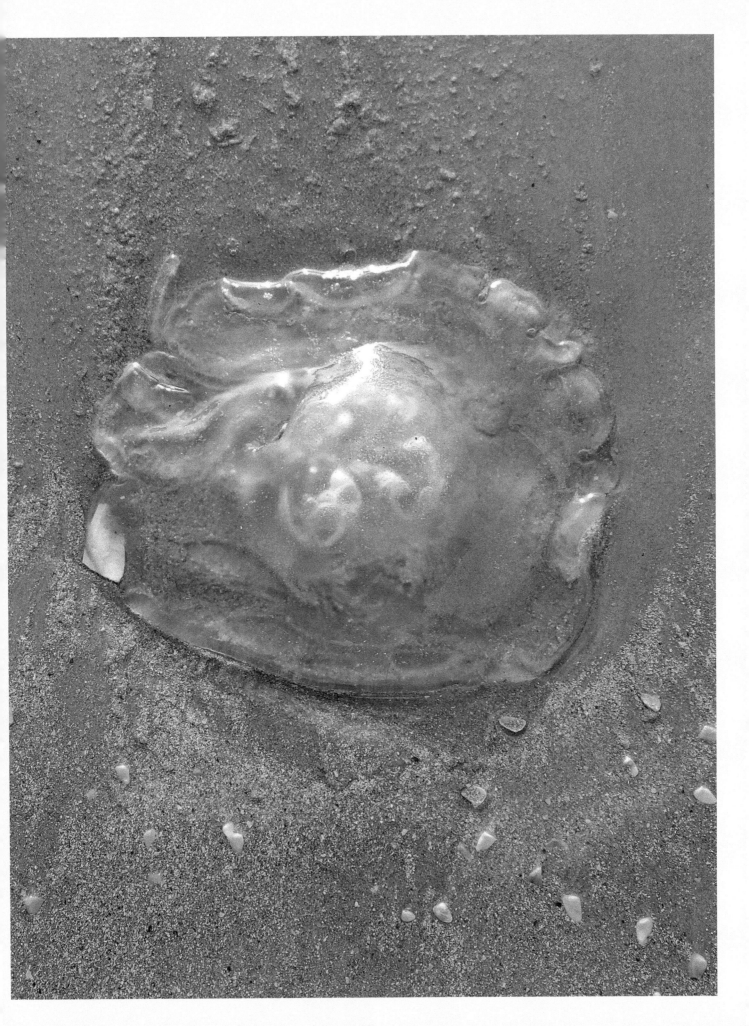

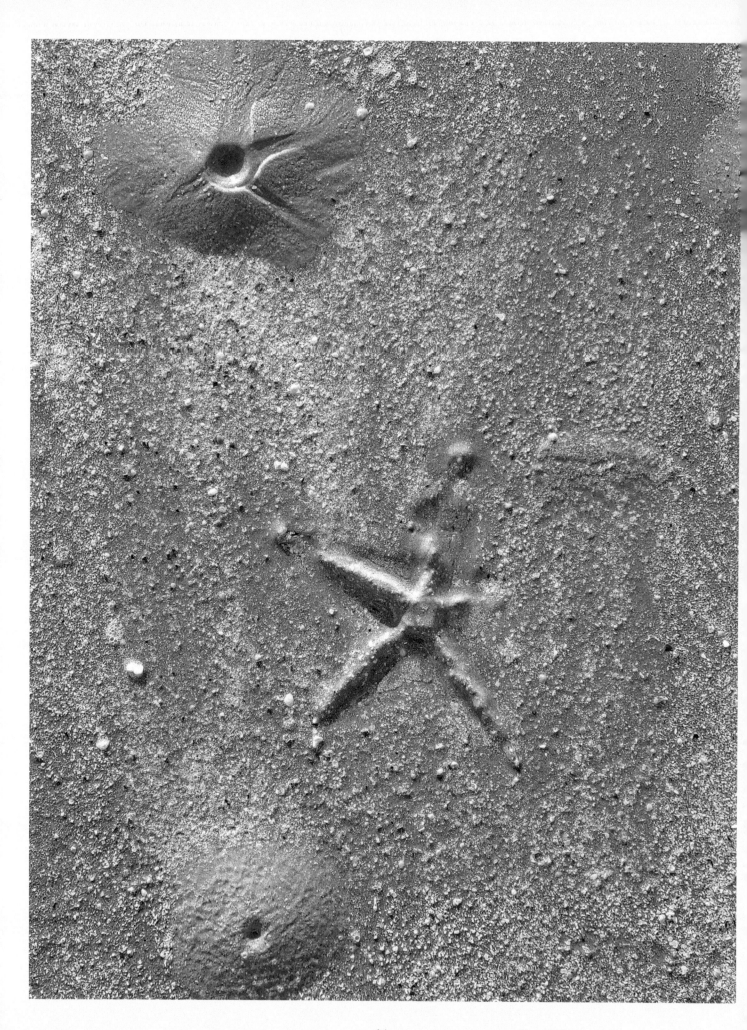

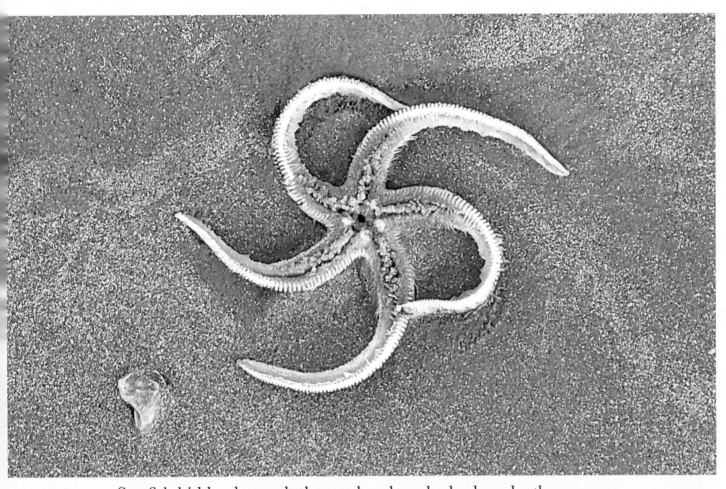

Starfish hidden beneath the sand and washed ashore by the waves.

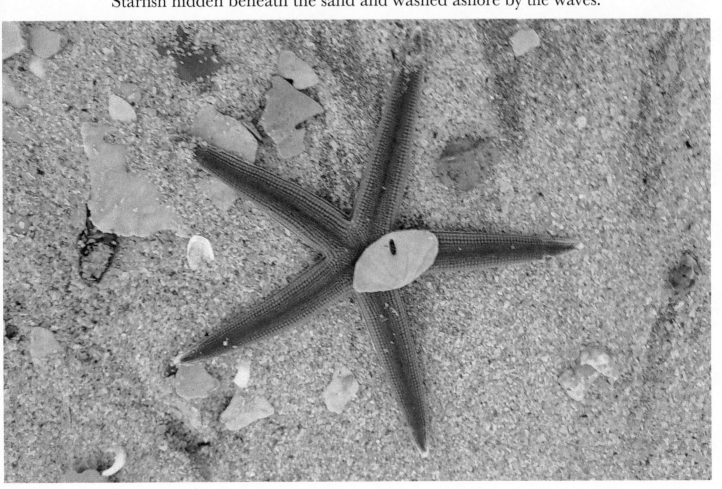

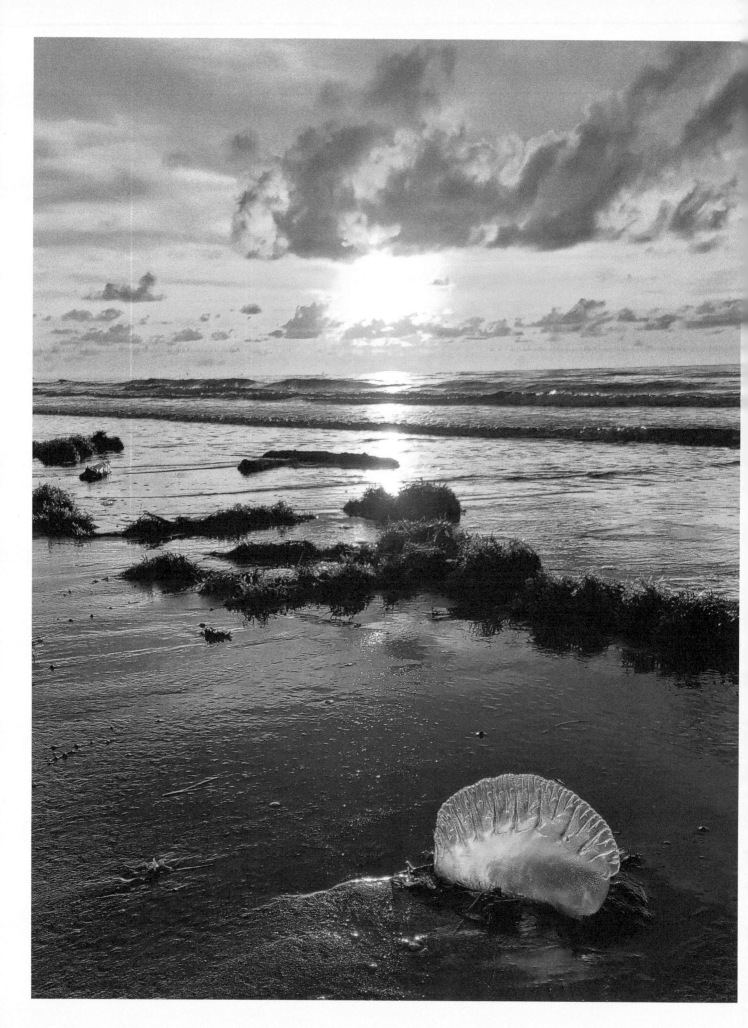

Light Shines through the War

As I walked the beach today,
The light shined through the man-o'-war.
Little whitecapping waves
rolled over close to the shore.

The shimmery blue sea
Caught my eye.
"Come play with me!"
Was the water's cry.

"Come sit by me awhile.
Write in your little book.
I love to see your smile
As you take a look."

Soaking in God's glory—it's all around.
Seeing…Smelling…Hearing the sounds.
Deep in your soul was agony and pain,
Felt like a broken hole—stress and strain.

But through that war,
Light shined through,
Bringing healing galore,
Peace, and calm to you!

Sand: Sculptures & Writings

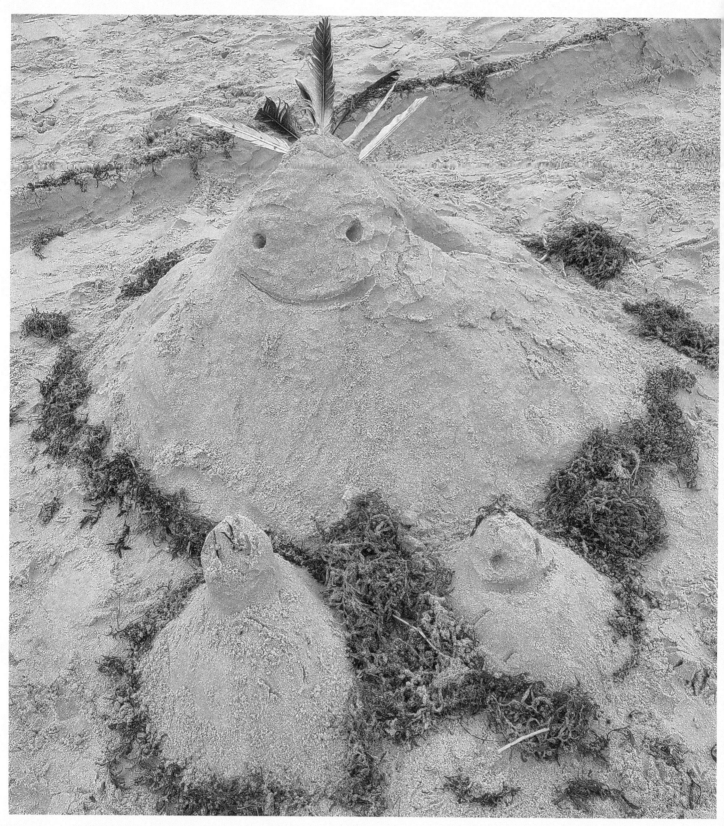

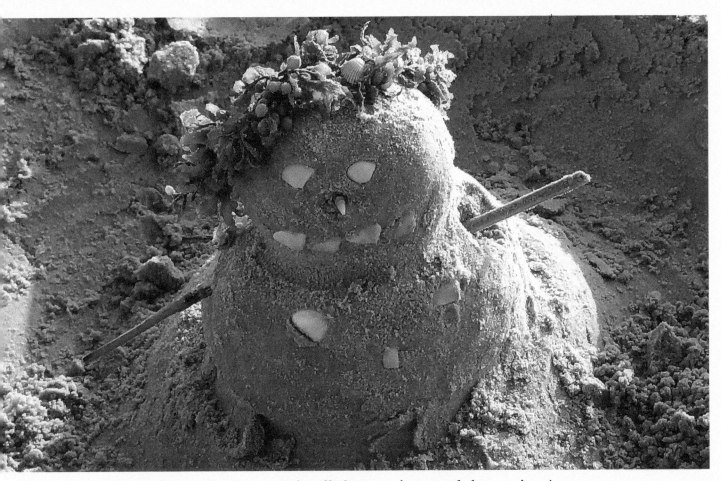

Sandmen show up in all shapes, sizes, and decorations!

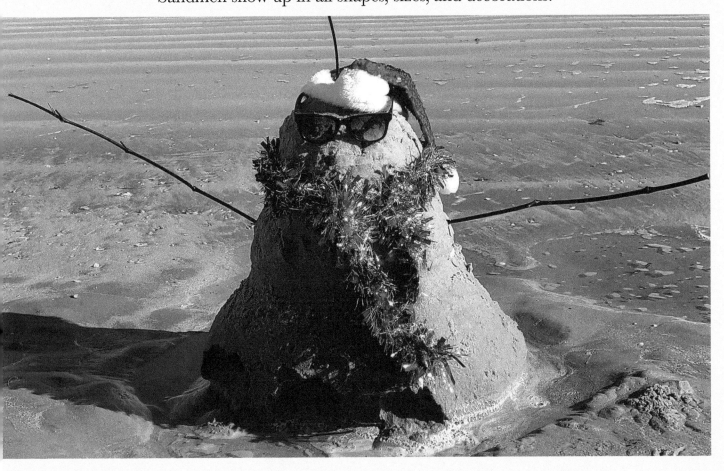

Christmas on the beach!

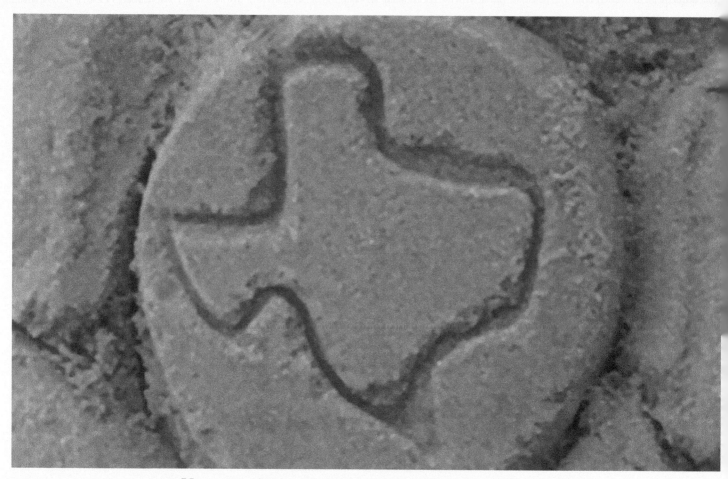

You never know what awaits your discovery! Texas!

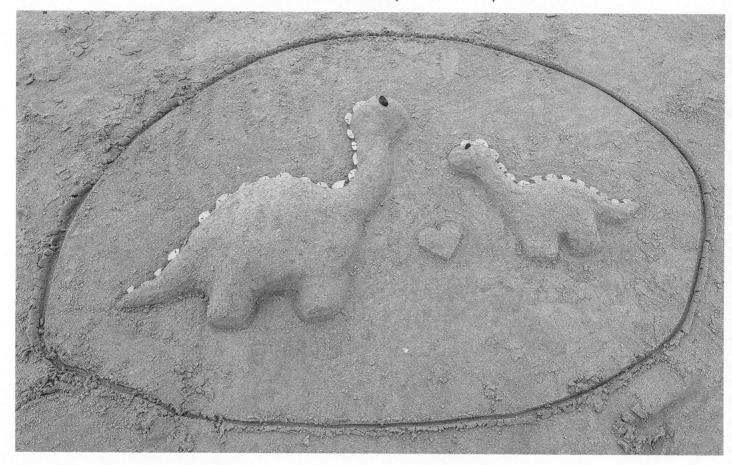

Dinosaur love!

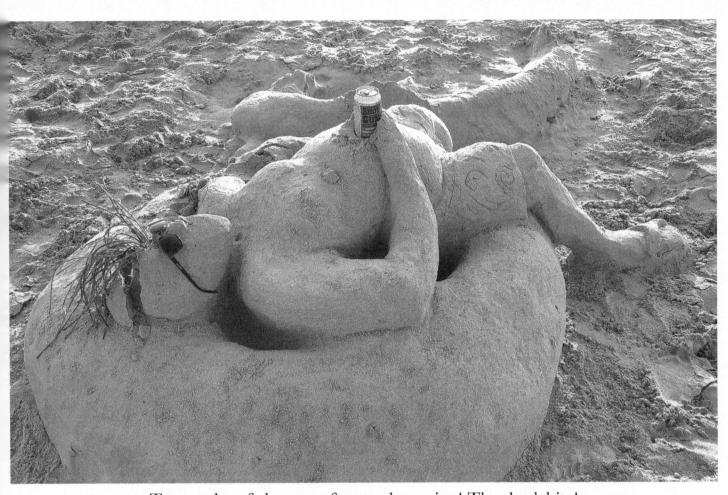

Two angles of the same fun sand creation! The shark bite!

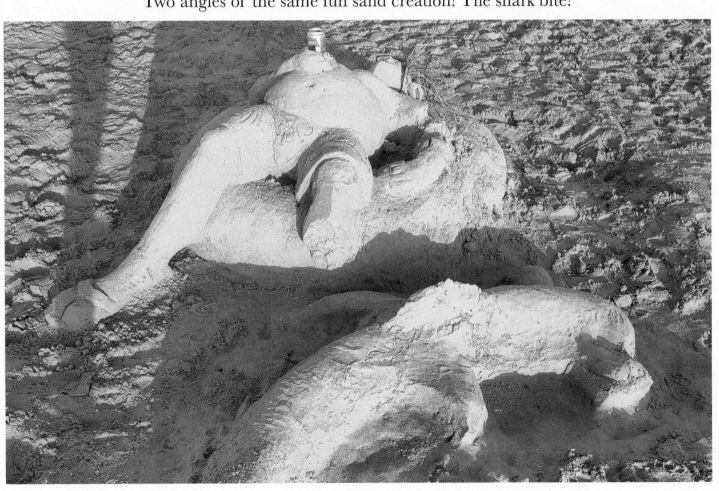

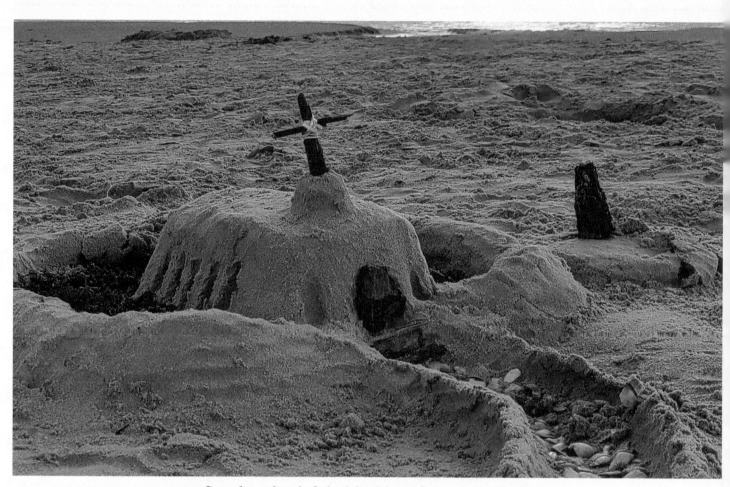

Sandcastles left behind just for me to find!
Thanks to all the creative people who bless my walks!

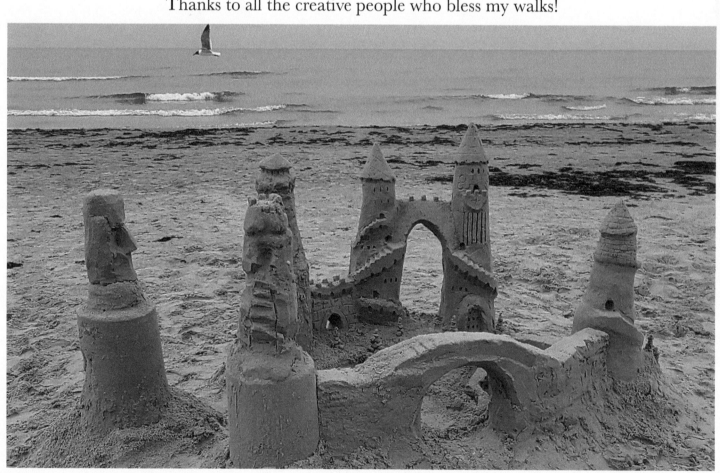

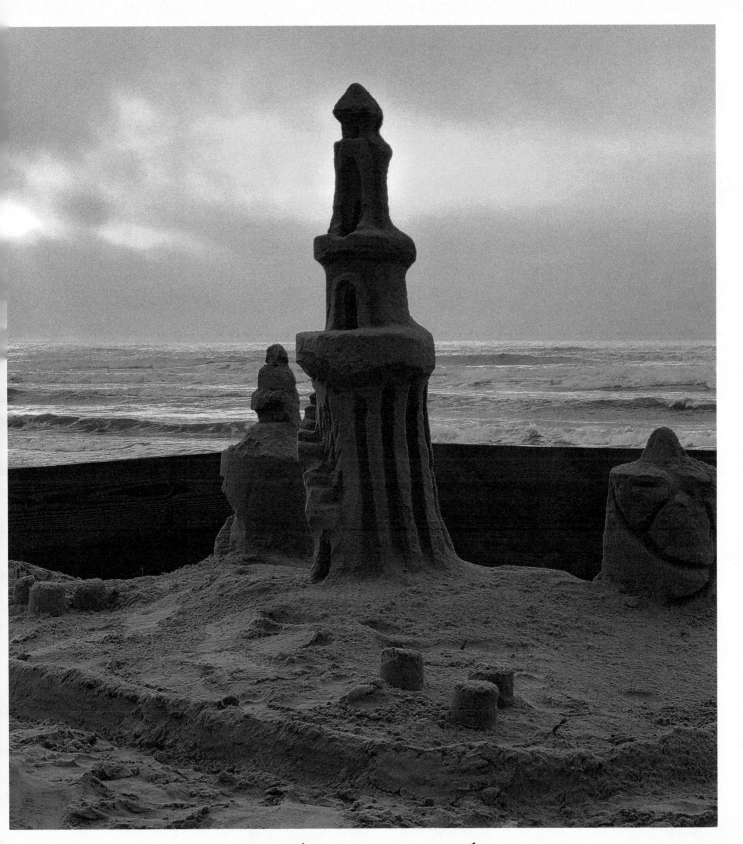

Sole to Soul

As I walked the beach today,
I splashed the water and giggled and played.
My soles sank deep into the sand.
My soul rested peacefully within your hand!

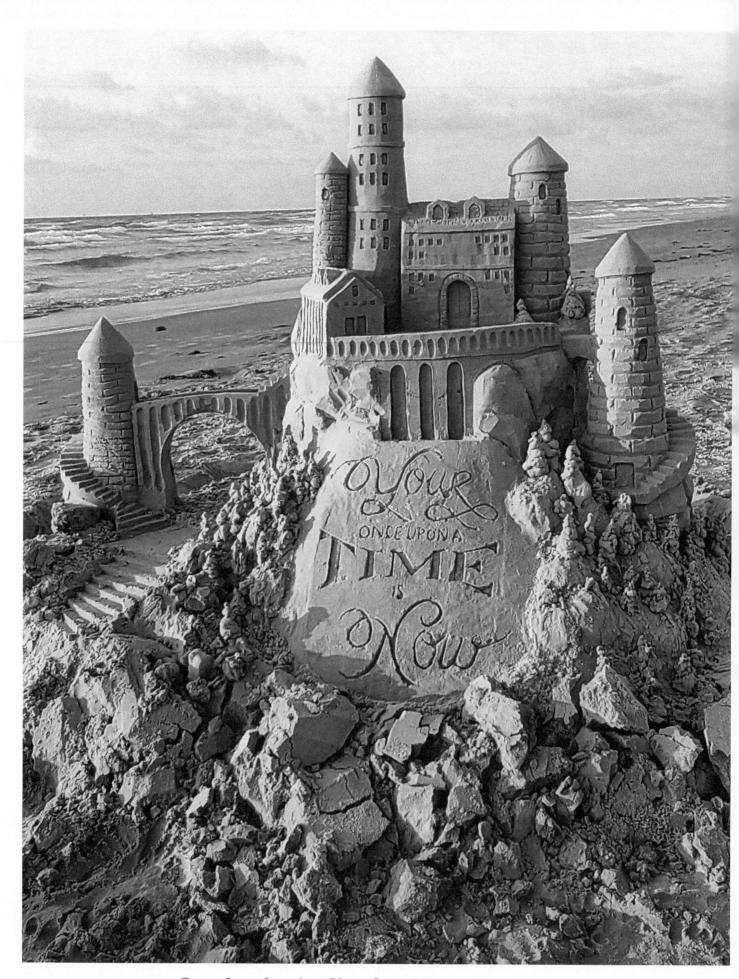

One of my favorites! Your Once Upon a Time Is Now!

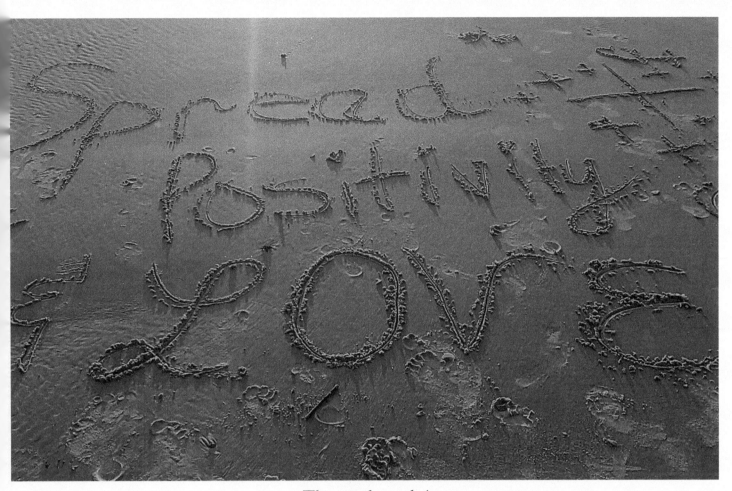

The sand speaks!

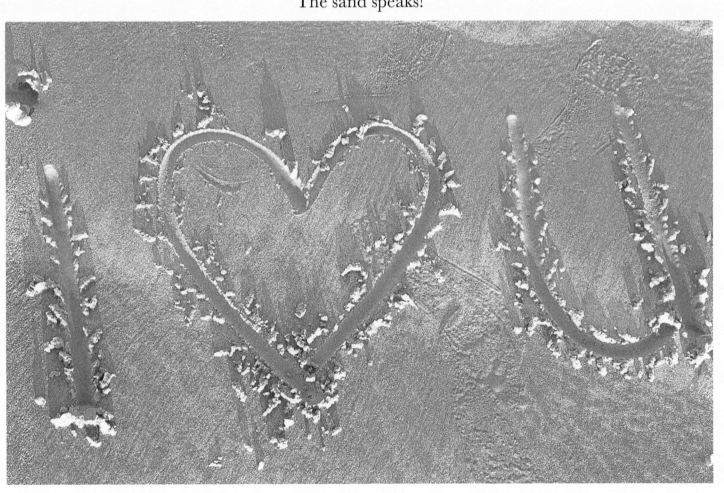

Reflections

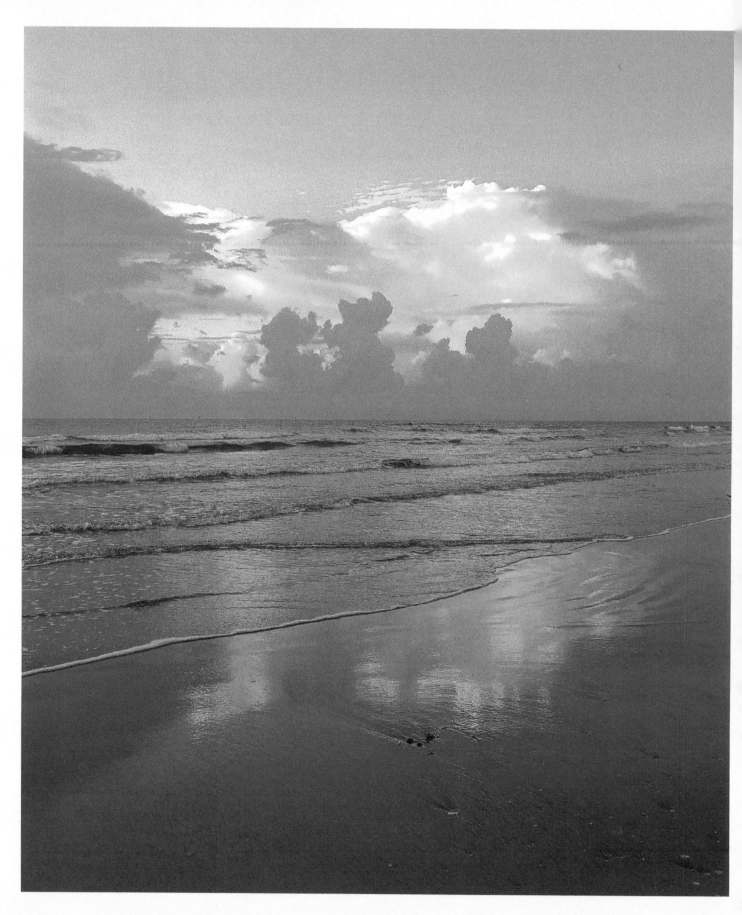

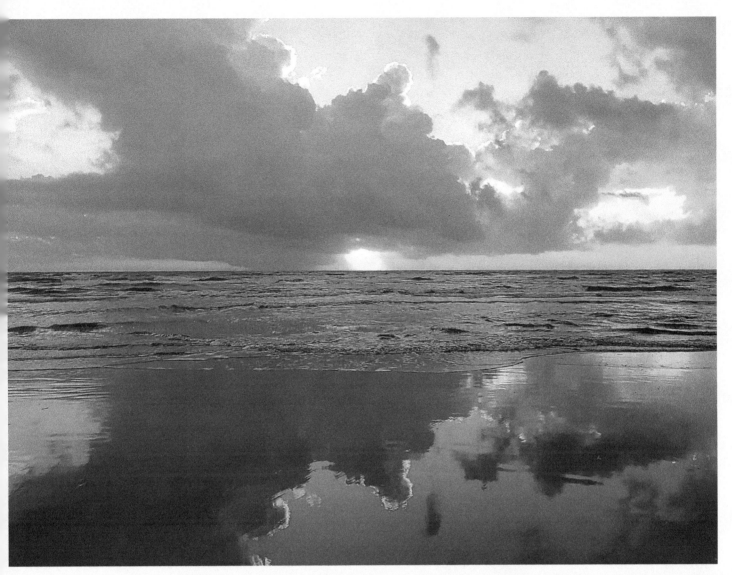

The Ocean and Me

The ocean and I speak a language we're privy,
Loving…Fun…Angry…Usually silly.

We share energy deep in our core,
Connected forever…even in turmoil.

The time here heals me…reveals who I am,
Salt, waves, and water—don't forget the sand.

Come, I invite you to experience it too.
Let the water wash away everything—find the real you!

Lively, spirited—we are both free.
I'm grateful; I'm thankful for the ocean and me.

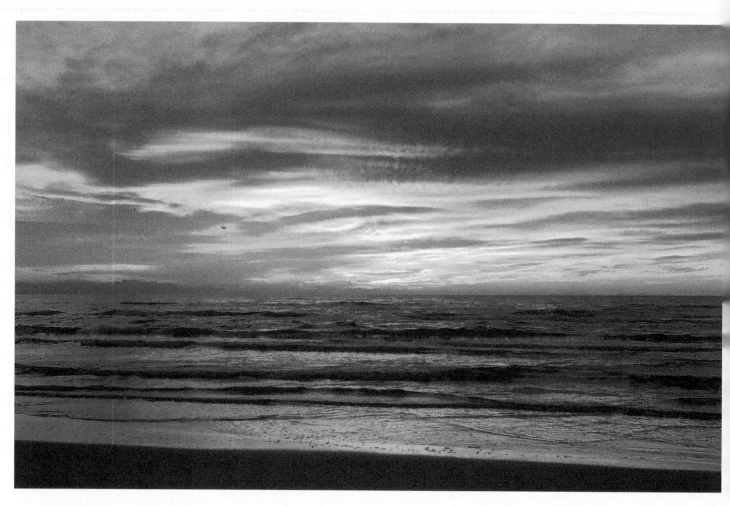

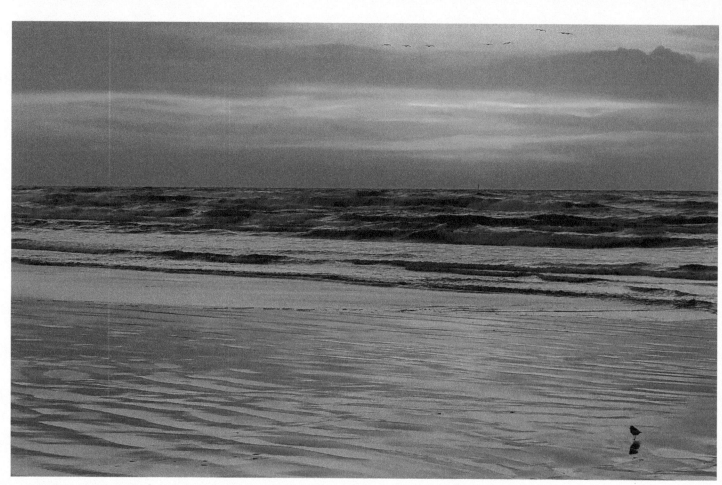

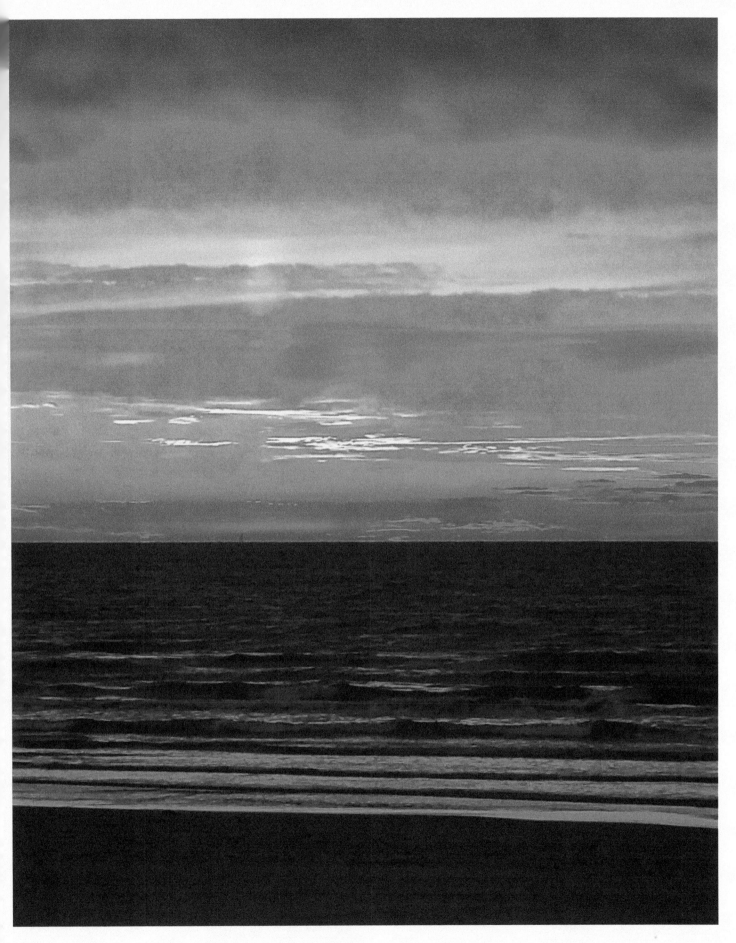

The clear water reflects the many colors of the painted sky.
God's palette and canvas are unique to each new day!

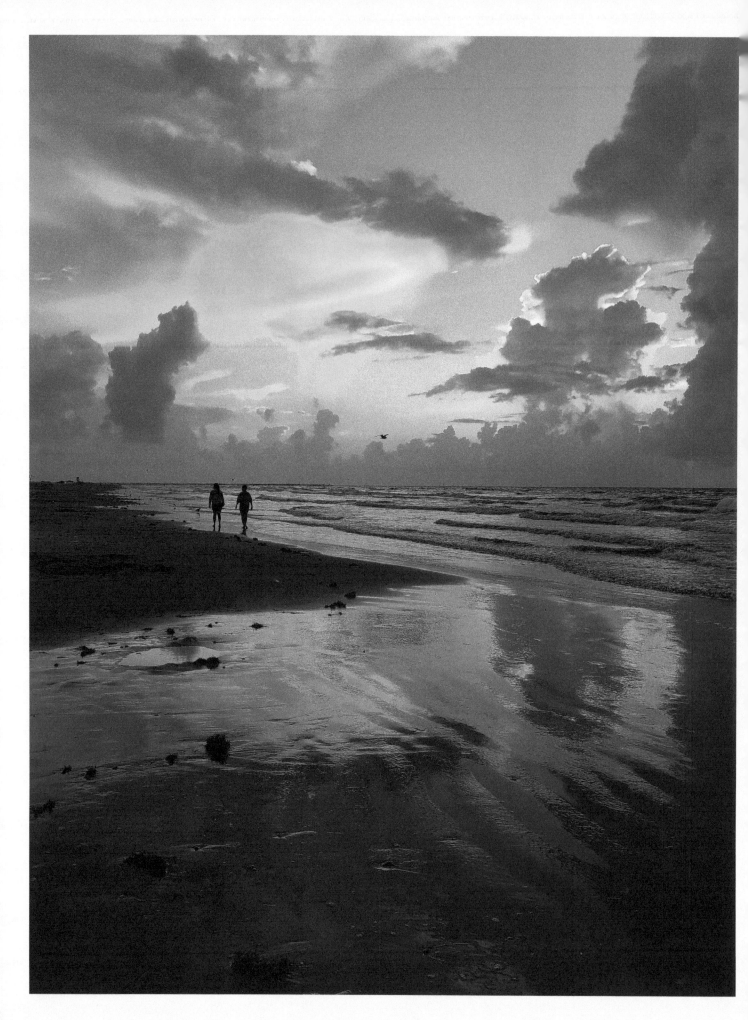

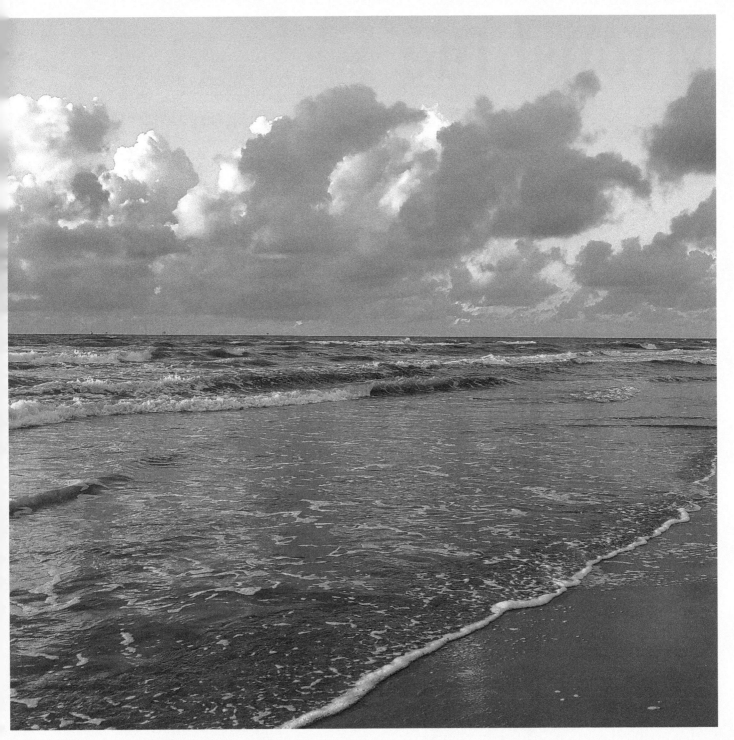

God Calming My Soul

Water tickling my toes,
Sand sinking under my feet,
Wind brushing my face, tangling my hair,
Sun warming my skin,
Waves laughing in my ears,
Ocean air filling my lungs,
Sea treasures catching my eye,
God calming my soul!

Moonshine

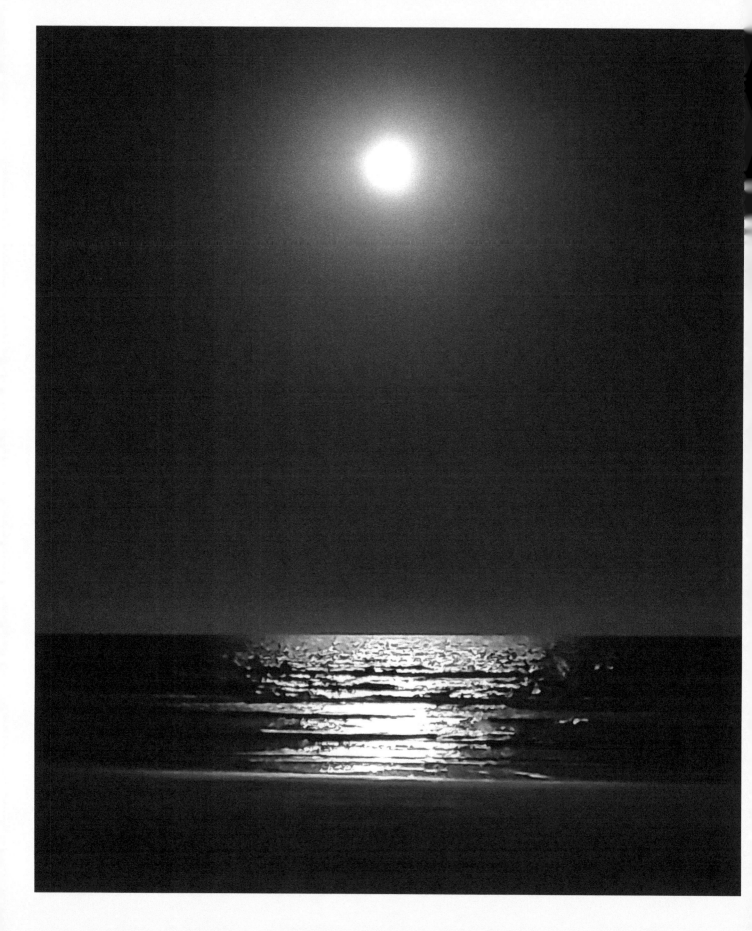

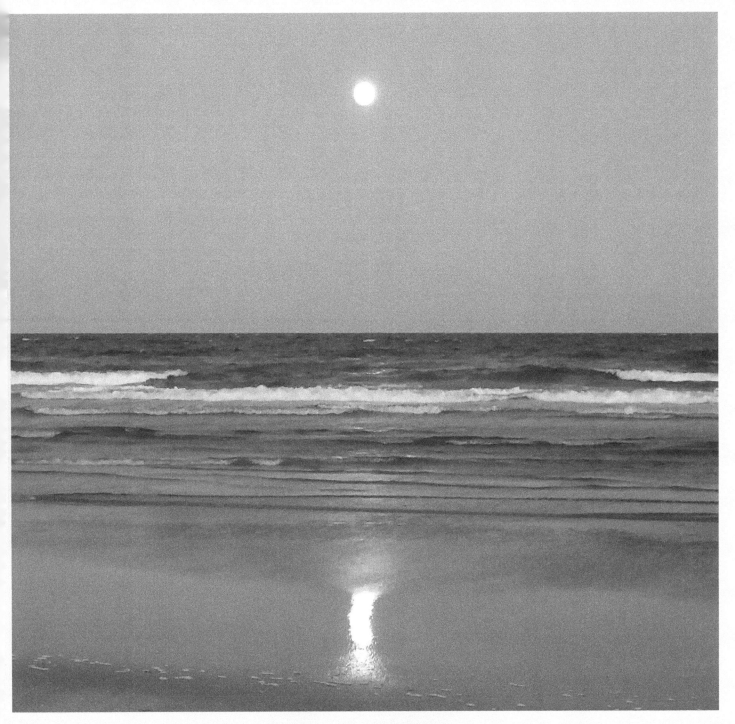

Moonlight

As I walked the beach tonight,
The water sparkled under the moonlight.

Quiet, lapping little waves,
Beachfront empty—people gone away.

The dark holds a beauty the day cannot.
I'm always ready for another beach walk!

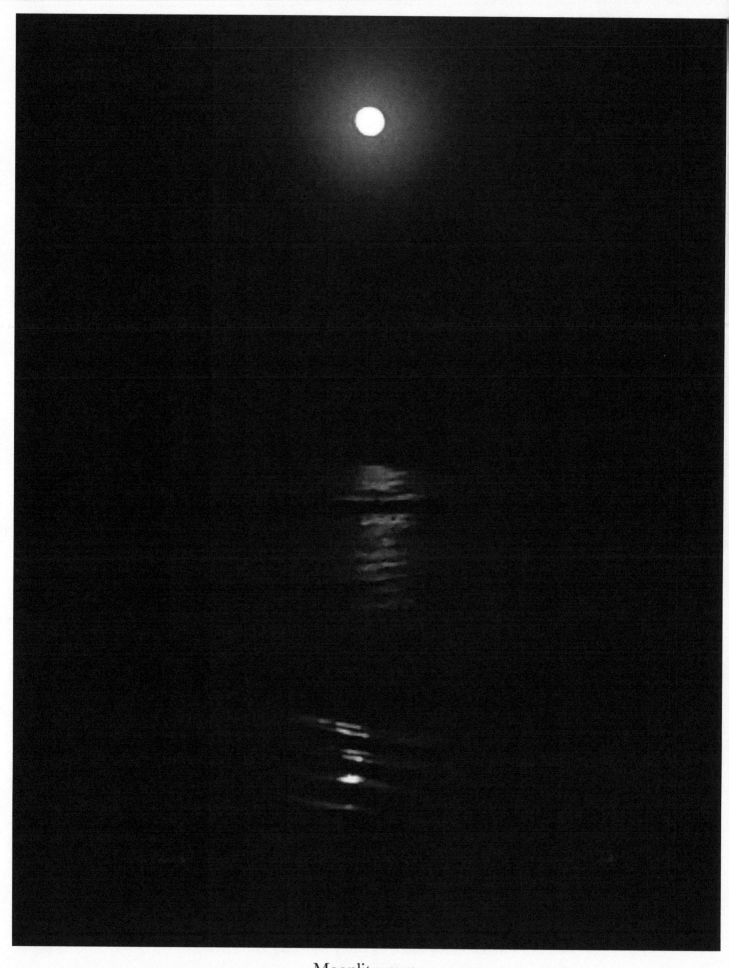

Moonlit waves

Lighting up the night sky!

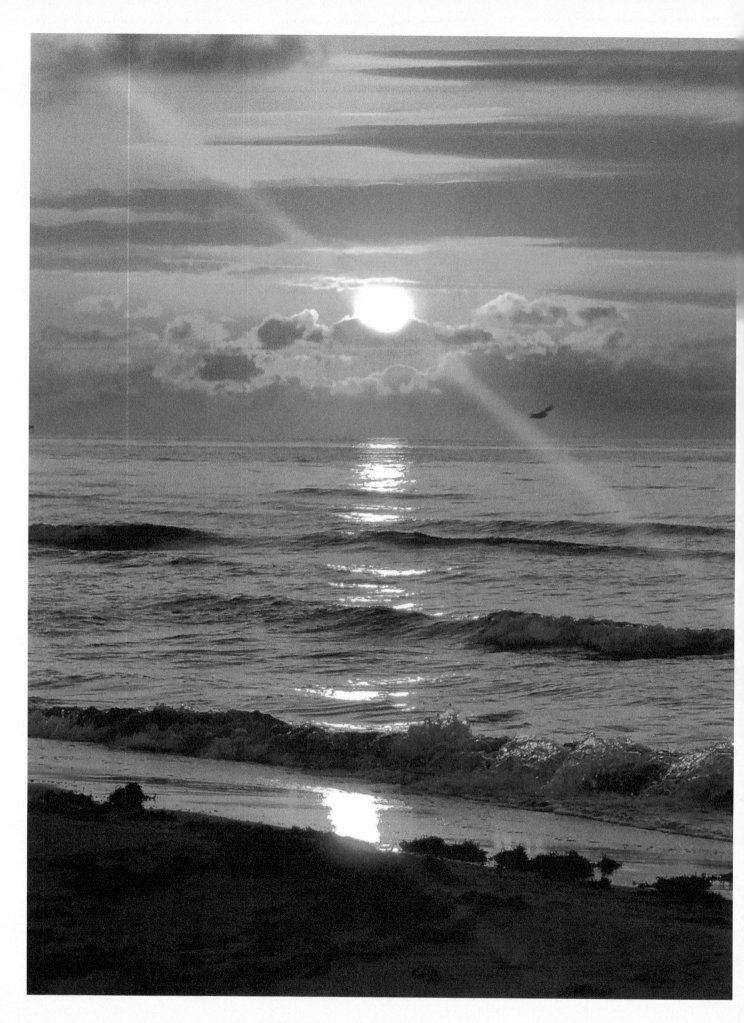

Sun Games Tomorrow?

As I walked my beach today,
The sun, silly, fun at play.
Upon rising, just peeking through the cloud,
Here I am, full-on shining proud.
Poof! I'm gone.
Can you see me now?

Keep looking back as you walk the other way.
I'm peeking through the clouds to make sure you're okay.

Wait! Here's all of me before you go.
I'll see you tomorrow for a whole new show!

Parting Words

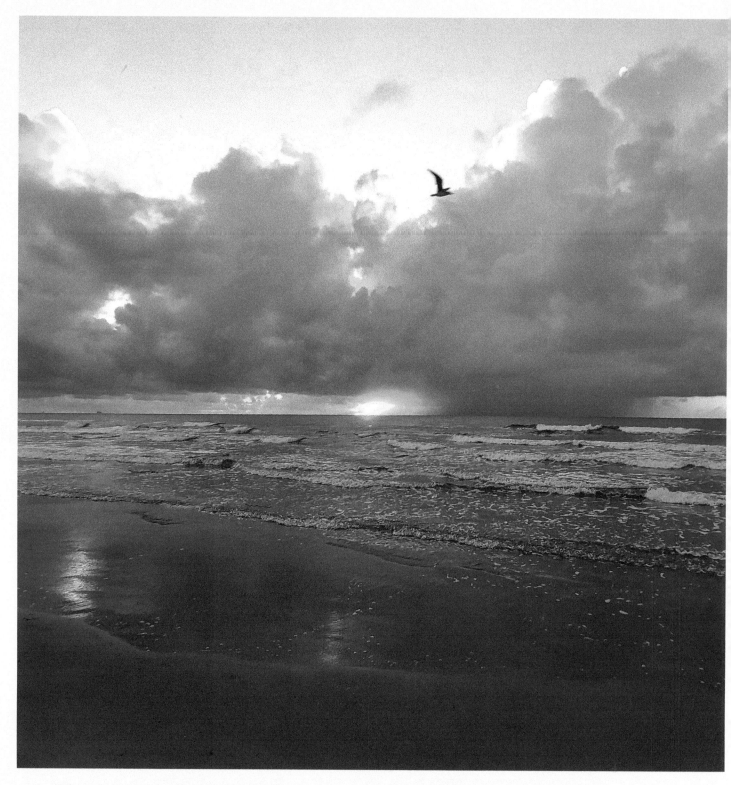

The picture is a depiction of life. Storms threaten to destroy us, but there is a beginning
and an end. Light shines beautifully while we fly with peace.
My life shattered several years ago, and walks on the beach aided in my healing.
Healing opened my imagination—holding letters, forming words, constructing poems.

The Struggle Is Real

As I walked the beach today,
The Truth became very clear.
You, pushing and pulling me
To get me right here.

Struggling, wrestling, crying too,
Kicking and screaming in anger at You.
"GO AWAY!" I yelled…but Your arms held tight.
"I gotcha, girl! Come on, let's fight!"

Cuss, scream, do as you please.
I'm right here with you—I'll never leave!
I'm your Creator. I love you!
I formed you with everything to make it through!

Now let's get up together and do this life,
Kicking ass at succeeding through this strife!
I know the Truth—you've only been deceived.
I'm right beside you—just ask, believe, and receive.

Terrible and terrific—Truth still abounds,
Lessons and Blessings all around.
Let's take a breath and let those tears fall.
It's okay to not be okay in the midst of it all!

Now, look again.
What do you see?
The waves, sand, and water,
The sun, and you and me!

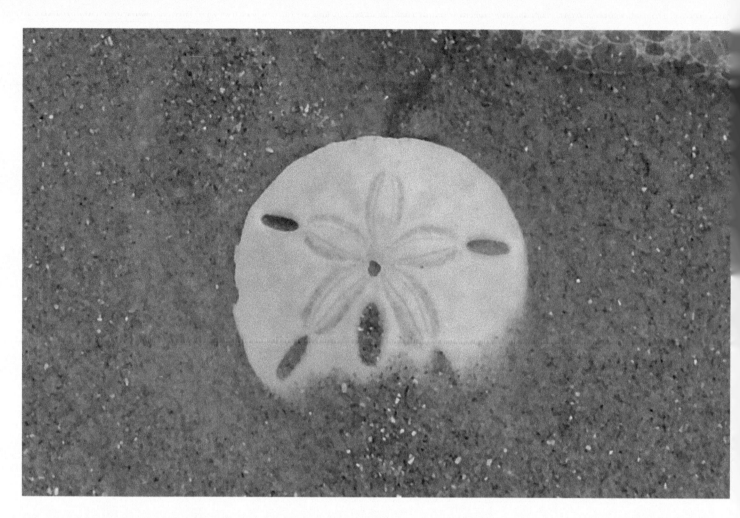

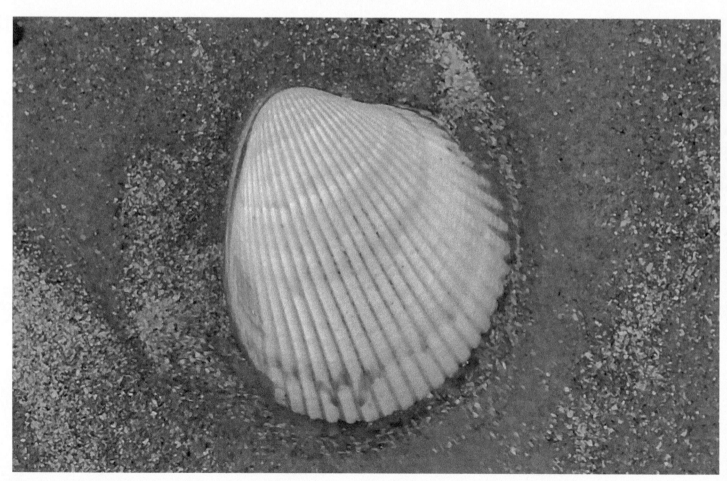

Acknowledgments

I've enjoyed scrolling through my pictures and putting my words with them onto paper, bringing this book to life.

To my grandkiddos—thank you for the fun beach walks on Gran-Li's Beach! I love joining your child-view adventures and delighting in everything we encounter along the way. Let's go!

To my children and children-in-law—thank you for the fun beach walks and time spent together, hanging out, playing in the sand and water! Thanks for always supporting my big dreams and for dreaming big with me! Your encouragement brought this baby to life!

To my son—Thank you for putting up with me while you patiently shot my author's photo!

To my parents—Thank you for taking me to Port Aransas many years ago to experience the beach that formed a lifelong love deep within me!

To Bro. Jo—Thank you for encouraging me to make "great" decisions and to buy my little beach condo even though I was scared. Your support made my dream happen and aided in my healing.

To my publisher, Lisa Umina—Thank you for your enthusiasm and excitement in taking on this second project.

To my chief editor, Danielle Roux Rodriguez—Thank you for your patience and continued clarification and communication while seeing this book brought to life!

To my assistant publisher, Fernanda Ramirez, and my HALO publishing team—Thank you for taking on this project and for your continued patience through to completion!

To you, the reader—Thank you for getting this book, reading it, admiring it, and sharing it! May it bring peace to your soul!

Living Beyond: The Night the Cops Showed Up

ISBN Paperback: 978-1-63765-210-7

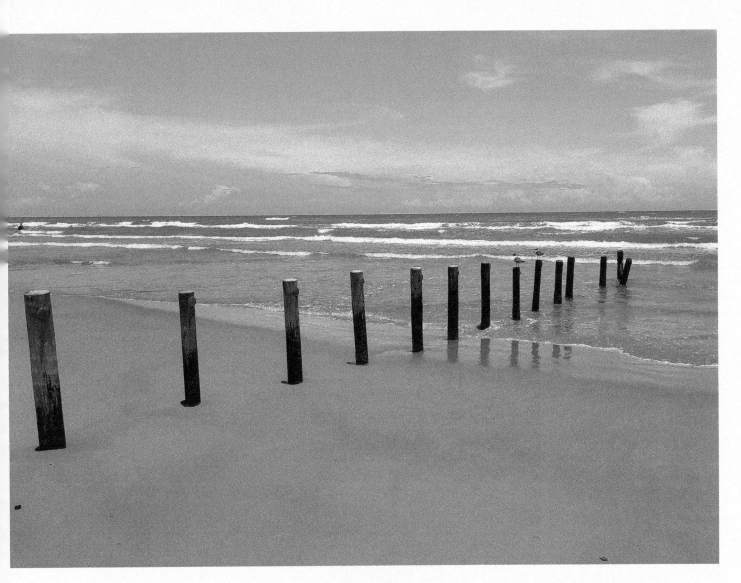

Let's Connect

Find out more about Clemmie-Li Clyde at the following links!

Email: clemmieli.clyde@gmail.com

Facebook: Clemmie-Li Clyde

Instagram: @clemmie_li_clyde

Printed in the USA
CPSIA information can be obtained
at www.ICGtesting.com
LVHW072044151023
760421LV00003B/13